FOUR MODERN MASTERS:
DE CHIRICO, ERNST, MAGRITTE, AND MIRO

Organized under the auspices of The
International Council of The Museum of Modern Art,
New York, and made possible by grants from
Norcen Energy Resources Limited and The Royal Bank

Published for the exhibition *Four Modern Masters*
November 23, 1981 to January 10, 1982 by
Glenbow Museum, 130 - 9th Avenue S.E.
Calgary, Alberta, Canada

Organized under the auspices of
The International Council of
The Museum of Modern Art, New York
and made possible by grants from
Norcen Energy Resources Limited
and The Royal Bank who also subsidized
the publication of this catalogue

 ISBN 0-919224-23-7

Contents

Foreword

We are very pleased to have the opportunity to bring to Canada this extraordinary collection of the works of four twentieth-century artists who have changed the course of the art of our time as well as our way of seeing: Giorgio de Chirico, Max Ernst, René Magritte, Joan Miró.

It seems to us particularly fitting that the Glenbow Museum will play host to this exhibition of world importance at the very moment when the city of Calgary is burgeoning with self-awareness and a consciousness of leadership, not only in business, but in the arts as well.

H. E. Wyatt
Vice-Chairman
The Royal Bank of Canada

E. G. Battle
President and
Chief Executive Officer
Norcen Energy Resources Limited

Preface

The presentation of *Four Modern Masters: de Chirico, Ernst, Magritte and Miró*
at the Glenbow Museum is an event of significance. The exhibition was organized
under the auspices of The International Council of The Museum of Modern Art,
New York for a tour of Sao Paulo, Buenos Aires and Caracas in the summer and fall
of this year. Subsequently the Glenbow Museum was invited to become the
fourth and only North American venue. To the best of my knowledge this is the first
time that a major exhibition from The Museum of Modern Art has been shown in
a western Canadian museum or art gallery. The invitation to Glenbow implies a
growing awareness of the cultural vitality of the West in world art centres. The
generosity of The Museum of Modern Art in extending this exhibition's tour is very
much appreciated and the assistance and co-operation of the staff of the museum is
gratefully acknowledged.

Accepting the invitation meant that Glenbow had to seek substantial support from
the private or corporate sector and our sincere thanks must go to Mr. Edmund C.
Bovey, Chairman of The Council for Business and the Arts in Canada and a
member of The International Council of the museum. Through his good offices we
obtained substantial grants from Norcen Energy Resources Limited and The Royal
Bank. Without this support the exhibition in Calgary would not have been possible.
This further evidence of growing corporate support of the arts in Alberta again
suggests the vitality and positive directions of cultural development in the West.

The exhibition itself has, of course, its own significance. The Museum of Modern Art
is unique among world museums, holding the most comprehensive collections
of the art of the twentieth century, encompassing not only painting and sculpture,
prints and drawings, but also architecture and industrial design, photography and
film. From this incredible resource the museum can produce an exhibition like the
one before us, focussing on four great masters associated with Surrealism, each
vastly different from the others but together informing us of the principal tenets
of Surrealism.

Such an opportunity to have our eyes and our minds opened will come rarely to
those of us who live far from the great art centres of the world. Fortunately our
museums and art galleries share with each other as members in an international
community and I trust that many will seize this very special opportunity and enjoy
the privilege of that membership.

Duncan F. Cameron
Director
Glenbow Museum

Introduction and Acknowledgements

The work of each of the artists represented in this exhibition has played a critical role in the evolution of twentieth-century art. Identified with Surrealism, their work exemplifies the diversity of styles encompassed by that movement which has proved so crucial to the development of painting since the Second World War.

De Chirico's pictures of the second decade of this century anticipated and influenced the course of Surrealism, as well as incorporated within representational formats many aspects of abstract avant-garde movements of the period. Ernst was the total Surrealist. In his development of *frottage* he was in the vanguard of Surrealism's first abstract period of the 1920s, and in the succeeding decade one of the finest practitioners of the realistic portrayal of the dream image. Throughout the rest of his long career he produced works that move convincingly between these polarities of Surrealist expression. Miró was the pioneer *par-excellence* of Surrealism's first "heroic" years of the 1920s. The Surrealist concepts of automatism and *peinture-poèsie* find their highest and most radical development in his art which, although it is always referential in some way, is often pushed to the very brink of abstraction. Magritte never deviated from the representational, but the inventiveness and fantasy with which he manipulated both paint and collage-derived techniques of surprise place him in the first rank of the illusionist side of Surrealism.

As the importance of the four artists represented in this exhibition has long been recognized, an extensive literature exists on each. We have accordingly elected in this catalogue to provide commentaries on individual works rather than a general essay that could only re-work and précis what is readily available elsewhere.

The collection of The Museum of Modern Art has provided the single largest source of works for this exhibition. The extraordinary bequest of the late James Thrall Soby alone accounts for half of the representation of de Chirico. Rich as the museum's collection is, this exhibition would not have been possible without the exceptional generosity of many lenders both public and private. On behalf of The International Council of The Museum of Modern Art, we would like to register our most profound gratitude to the following lenders: Museum Ludwig, Cologne; Los Angeles County Museum of Art; Pierre Matisse, New York; Menil Foundation, Houston; Morton Neumann, Chicago; The Solomon R. Guggenheim Museum, New York; Richard S. Zeisler Collection, New York; and two collectors who wish to remain anonymous.

Many members of the staff of The Museum of Modern Art have contributed to the realization of this exhibition. Foremost among them are Waldo Rasmussen, Director of the International Program, and Elizabeth Streibert, Assistant Director of the International Program. Their assistance and commitment to this project have been essential to its realization. We are also deeply grateful to Richard E. Oldenburg, Director of the museum, and to William Rubin, Director of the Department of Painting and Sculpture, for their encouragement and support.

For organizing the complicated logistics of this exhibition we owe special thanks to Marion Kocot, Vlasta Odell, and Cherie Summers. Many other members of the museum staff have also assisted in various ways; for their expert and valued help we would like to thank Diane Farynyk, Kate Keller, Doris Ng, Mali Olatunji, Ruth Priever, Cora Rosevear, Richard Tooke, and Susan Weiley.

Carolyn Lanchner and Laura Rosenstock
The Museum of Modern Art, New York

Giorgio de Chirico

1888
Born July 10 in Volo, Greece, of Italian parents—Evariste, an engineer for the railroad lines, and Gemma.

1891
Birth of Andrea, his brother who, as a musician, writer, and painter, was known as Alberto Savinio (an older sister died very young).

1900
Enrolls in drawing classes at the Polytechnic Institute in Athens.

1905
His father dies.

1906-09
Family moves to Munich, stopping in Venice and Milan. Giorgio attends the Academy of Fine Arts for two years. Becomes acquainted with the writings of Schopenhauer, Weininger, and Nietzsche and the art of Arnold Boecklin and Max Klinger.

1909
Returns to Milan. Paints Boecklinesque canvases.

1910
Lives with his mother in Florence. Suffers from intestinal disorders. Paints pictures which prefigure metaphysical paintings.

1911
Leaves via Turin for Paris with his mother to meet Andrea.

1912
Develops metaphysical style. Exhibits three paintings in the Salon d'Automne.

1913
Exhibits three works at the Salon des Indépendants and four at the Salon d'Automne. Guillaume Apollinaire begins to mention him in articles.

1914
Most prolific year of early career. Frequents the literary and artistic milieu of the Ecole de Paris. Exhibits three works at the Salon des Indépendants.

1915
Recalled to Italy because of the outbreak of war; assigned to infantry regiment in Ferrara. Brother and mother also in Ferrara.

1916-17
Because of ill health is given job at headquarters and is able to continue painting important works. Meets Carlo Carra and with him forms the Scuola Metafisica.

1918
Demobilized, then departs for Rome with his mother.

1919
One-man exhibition held at the Anton Giulio Bragaglia Gallery, Rome, is harshly criticized. Collaborates in producing articles for Mario Broglio's magazine *Valori Plastici*. Paintings exhibited in Berlin. Has a "revelation" in the museum of the Villa Borghese which sets his work in a more traditional direction.

1920
Divides his time between Rome and Florence. Reverts to academic standards and studies the work of earlier painters. His style fluctuates between neo-classicism and the Baroque.

1921
One-man show in Milan.

1922
Writes to André Breton about his thoughts on painting.

1924
Participates in the Venice Biennale.

1925
Returns to Paris. Exhibits in Léonce Rosenberg's Galerie de l'Effort Moderne and is violently attacked by the Surrealists.

1926
Exhibits in Paris at the Galerie Paul Guillaume.

1928
One-man exhibition in London at the Arthur Tooth Gallery. Jean Cocteau publishes *Le Mystere Laïc* with lithographs by de Chirico. Despite the controversy with the Surrealists and the attacks by Breton and Aragon, major Dada and Surrealist artists (Max Ernst, Yves Tanguy, René Magritte, Salvador Dali) recognize their debt to de Chirico

1929-30
His novel *Hebdomeros* is published. Designs the scenery and costumes for the Diaghilev ballet *Le Bal*. Participates in many international exhibitions. Meets Isabella Far. Apollinaire publishes *Calligrammes* illustrated by de Chirico's lithographs. Returns with Isabella Far to Milan and exhibits there at the Galerie Barbaroux. One-man exhibition in Prague.

1932
Lives and works in Florence. Participates in the Venice Biennale.

1933
Designs scenery and costumes for the opera *I Puritani* by Vincenzo Bellini for the Maggio Musicale Fiorentino.

1934
Returns to Paris and prepares lithographs for Cocteau's *Mythologie*.

1935
One-man exhibition at the Quadriennale of Rome. Departs for New York during summer.

1936
Stays with Isabella Far in the United States. While there receives news of his mother's death.

1937-40
Returns to Italy. Various exhibitions in Milan, Paris, and London.

1942
One-man exhibition at the Venice Biennale.

1943-44
Spends the war years painting in Rome and Florence.

1945-54
Establishes himself permanently in Rome. Publishes *Memory of My Life* and, in collaboration with Isabella Far, *Comedy of Modern Art*. Designs scenery and costumes for the ballet *Don Giovanni* by Richard Strauss for the Rome Opera. Various exhibitions in Rome and Venice. His brother dies.

1955
Exhibition of works from his early metaphysical period at The Museum of Modern Art, New York.

1967
Compilation of the General Catalogue of works by Giorgio de Chirico begins with the authorization of the artist and Isabella Far.

1968
Exhibition at the Galerie Iolas, Milan, of works on new metaphysical themes. Begins to make bronze sculpture.

1969
General Catalogue of the graphic works of Giorgio de Chirico 1921-1969 is published and displayed at the Galerie La Medusa, Rome, in conjunction with an important exhibition of his graphics.

1970
First retrospective is arranged at the Palazzo Reale in Milan. Exhibition travels to the Kestner-Gesellschaft in Hanover. Exhibition at the Palazzo dei Diamanti in Ferrara.

1971
First volume of the General Catalogue of works by Giorgio de Chirico is published.

1972-73
Second and third volumes of the General Catalogue are published. Exhibition at the New York Cultural Center in New York (travels to the Art Gallery of Ontario, Toronto).

1973-74
Large exhibition of his works travels to Tokyo, Kyoto, Kamakura, and Nagoya, Japan.

1974
Fourth volume of the General Catalogue is published.

1975
Fifth volume of the General Catalogue is published. The Musée Marmottan, Paris, has an exhibition comprised of more than 100 of his works.

1976
Exhibitions in Brussels, London, and New York.

1978
Dies November 20 in Rome.

The Anxious Journey. 1913. Oil on canvas, 74.3 x 106.7 cm. The Museum of Modern Art, New York. Acquired through the Lillie P. Bliss Bequest

De Chirico's trains are more disturbing than most Freudian symbols of malaise invented by later artists. They cut to the core of ordinary experience. Sometimes they appear silently in the distance, evoking an almost physical longing for the reassurance of their sound. Then again they are animal-like, ferocious and caged, as in *The Anxious Journey.*

The locomotive in *The Anxious Journey* appears as a dream-like, menacing phantom, recognized suddenly, as when one is aware of a motionless snake in one's path. The nightmarish reality of the locomotive is sharpened by its emergence at the edge of a labyrinth of arches, winding in and out, leading nowhere. The painting is clearly a dream image, expressing the terror of being lost in a railroad station before an important journey, of trying desperately to to locate a train, only to discover it finally at the far end of an inaccessible corridor. The psychological meaning of such a dream is, of course, a more complicated matter. It cannot be deciphered accurately in this case without direct psychoanalytical evidence as to the painter's state of mind—and emotion—when the image was created. We do know, however, that at intervals throughout his early career de Chirico's imagination became dark and troubled. Certainly *The Anxious Journey* may be described as an obsessive work.

The Anxious Journey might have been influenced by Robert Delaunay's *St. Séverin* and his other paintings of architectural subjects in which Cubism's precepts are applied to a maze of Gothic forms. The theory seems plausible in view of the poet-critic Guillaume Apollinaire's admiration for Delaunay's art. Indeed, it is difficult to believe that Apollinaire would not have tried to communicate to his young Italian protégé some of his enthusiasm for the Cubist movement as a whole. Paintings by the leading figures in the movement were hanging in Apollinaire's apartment on the Boulevard Saint-Germain to which de Chirico went often in 1913 and 1914. *The Anxious Journey*'s dark, narrow tonal range, together with its use of huddled architectural forms, suggests that de Chirico was by now fully aware of the Cubists' leadership in the vanguard of pre-war art in Paris.

(adapted from Soby, *Giorgio de Chirico,* pp. 49, 56, 65)

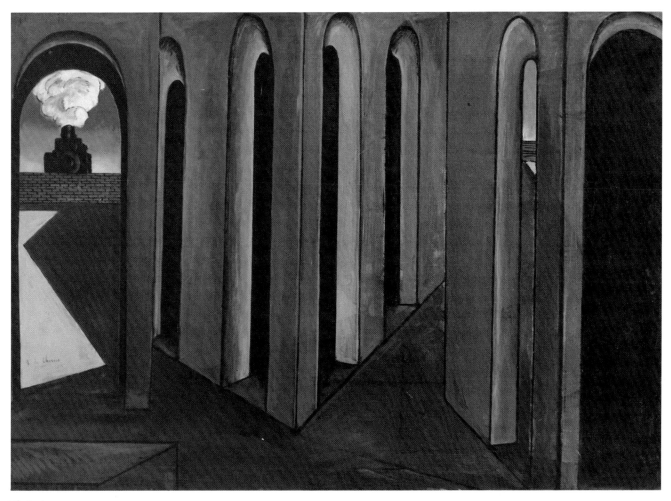

Plate 1

15

The Nostalgia of the Infinite. (1913-14? Dated on painting 1911). Oil on canvas, 135.2 x 64.8 cm. The Museum of Modern Art, New York

The Nostalgia of the Infinite is the climax of a series of paintings of towers. The date "1911" is inscribed on the painting but this is thought to be incorrect. (It may have been added to the signature by de Chirico at the time of his 1926 exhibition at Paul Guillaume's gallery in Paris.) *The Nostalgia of the Infinite* is far too mature a work to have been finished before late 1913 or early 1914. It was first exhibited publicly at the Salon des Indépendants in the spring of 1914, together with two pictures completed during the year preceding the Salon's opening. As well, there is no reason to imagine that de Chirico would have held so important a painting in reserve for several years before submitting it to a major Salon; between 1911 and the opening of the Salon des Indépendants of 1914, the artist had exhibited twice at the Salon d'Automne and once at the Indépendants.

Even more conclusive as to the true date of *Nostalgia* is the fact that it represents so drastic an advance in conception and technique over *The Tower*, which has been attributed to 1911-12. It is indeed more luminous and rich than the dated *Great Tower* of 1913, and therefore was probably completed very late in 1913 or early in 1914, just before the Salon opened. The false date on *Nostalgia* has done much to confuse the chronology of de Chirico's early career.

The central structure in *Nostalgia* is a square tower rather than a round one, as in two previous versions of the same general subject. The composition is more complex than in other works of the series, and includes a number of the most effective properties of de Chirico's strange world of reverie—a foreground box or abandoned van; a portico sliding into view; a shadow cast by an unseen presence; two tiny figures dwarfed by their vast setting; ghoulish, empty windows in the tower whose pennants blow vigorously amid an atmosphere otherwise totally inert. The image is especially piercing and memorable in that its thin pigment is luminous, almost incandescent, as though lighted from beneath the canvas.

If *Nostalgia* evokes an extraordinary dream-like illusion of infinite space and quiet, we must not disregard the skilful plastic means through which the illusion has been achieved. Because de Chirico was intent on restoring to painting a sense of poetic mood (and this in an era when most advanced artists were bitterly repenting Romanticism's ecstasies and tears), his early art is often judged solely by lyric as opposed to classical standards, a fact he himself protested at the time of his first one-man show, held in Rome in 1919: "The word *metaphysics* with which I have christened my painting ever since the time when I worked in Paris during the subtle and fertile pre-war years, caused annoyance, bad humor and misunderstandings of considerable proportions among the quasi-intellectuals on the banks of the Seine. The customary sarcasm, which soon degenerated into a hackneyed phrase, was: *c'est de la litterature.*"

It is true, of course, that nearly all of de Chirico's early paintings are dominated by their content of dream interpretation and in this sense might conceivably be thought of as "literary" on casual glance. But the hushed spatial serenity of *Nostalgia* is achieved through a quite abstract handling of form, testifying to the atavistic impetus of the artist's Renaissance heritage. The image is one of the most concentrated in all of de Chirico's early art. It is also an eloquent illustration of the philosopher Nietzsche's theory, proposed in the *Will to Power* —"The phenomenal world is the adjusted world which we believe to be real."

(adapted from Soby, *Giorgio de Chirico*, pp. 51-52)

16

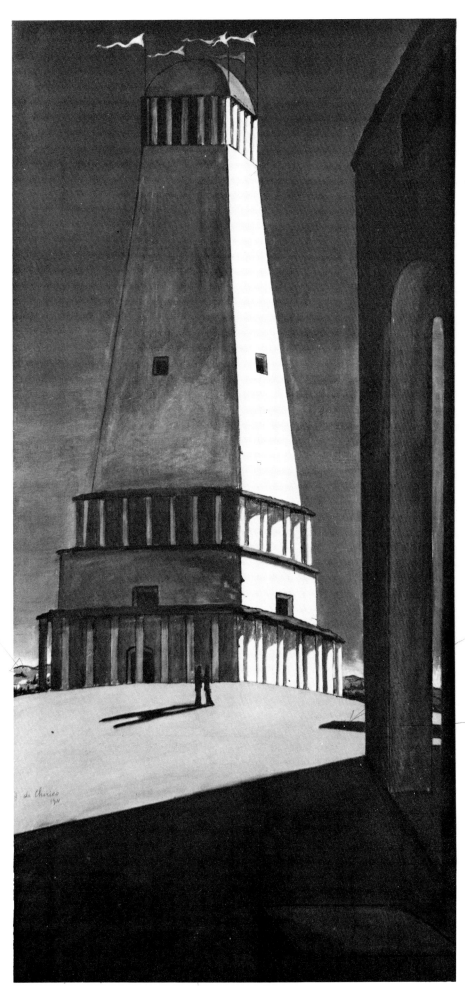

LAYERING

MASKING

ENCLOSURE

Plate 2

THRESHOLD

The Evil Genius of a King. (1914-1915). Oil on canvas, 61.0 x 50.2 cm. The Museum of Modern Art, New York

De Chirico did not fully develop his mannequin theme until 1915. Meanwhile he had begun a series of still lifes whose contents are especially cryptic; this series includes *The Evil Genius of a King.* All of the paintings in this series are related in compositional format. Their foreground areas rise steeply to form a kind of tilted ramp or platform that protrudes above the ground level of the architecture in the background and divides the compositions asymmetrically. Instead of enticing the observer to enter an open and illusory pictorial space, as in an earlier series of Italian piazzas, these paintings force him to climb to a dizzy vantage point high above the ground. The still-life elements strewn along the ramps, or vertical boards swung sideways, are unusually fantastic. If some of the objects can be identified with certainty, others seem thoroughly "unreal."

The party favours, ball and flower of *The Evil Genius of a King* are things de Chirico might have seen on his solitary walks through Paris but other forms in the painting seem to have no tangible basis in reality. In both cases the objects are depicted with precision for a definite reason. Just as the Cubists at this time were affixing sand, bits of string, and other commonplace materials to their canvases, in order to affirm an essential contact with reality, so de Chirico was eager to propose his fantasies in the most convincing manner possible. But above all he wished the poetry of his art to reside in unexpected juxtapositions taking place in an unlikely locale. He must have conceived of the artist's function as that of documenting metaphysical shifts in the continuity of everyday, settled reality. Apollinaire's respect for the element of "surprise" in painting comes to mind.

In choosing objects for still life that would provide new combinations for traditional juxtapositions, de Chirico appears to have relied on a more or less total inspiration that he ecstatically transferred to canvas. He makes the matter clear in the following statement: "The revelation we have of a work of art, the conception of a picture *must* represent something which has no sense in itself, has no subject, which from the point of view of human logic *means nothing at all.* I say that such a revelation (or if you like, conception), must be felt so strongly, must give us such joy or such pain that we are obliged to paint, impelled by a force greater than the force which impels a starving man to bite like a wild beast into the piece of bread he happens to find."

Thus de Chirico's prime creative asset was his susceptibility to a kind of self-hypnosis. He seems helplessly involved in the strange happenings of his genius, like an amateur delighted by bewildering success. One feels that he has watched the objects accumulate in *The Evil Genius of a King* as a child watches the contents of a Christmas stocking pour out onto the floor, not knowing what will come next and exclaiming at the miracle of what has already appeared.

The Evil Genius of a King is far stronger and brighter in colour than the still lifes and architectural scenes of 1913 and early 1914; in fact it is more brilliant in tone than many of the paintings de Chirico was to complete at Ferrara in 1916 and 1917. Quite likely the picture was completed very late in 1914 or early in 1915. The title itself suggests that it was painted after the outbreak of war in August 1914. De Chirico speaks in his autobiography of his shock and horror at the advent of war, and the ironic titles of this series may allude, however indirectly, to the events at hand.

(adapted from Soby, *Giorgio de Chirico*, pp. 98-101)

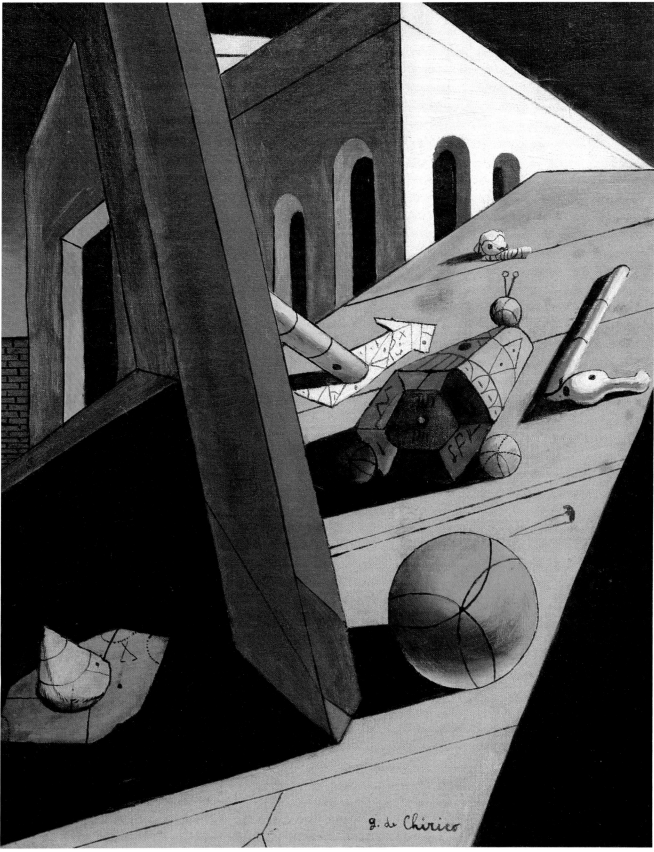

g. de Chirico

Plate 3

19

The Double Dream of Spring. 1915. Oil on canvas, 56.2 x 54.3 cm. The Museum of Modern Art, New York. Gift of James Thrall Soby

The Double Dream of Spring is a companion piece to *The Duo* (Plate 5) and *The Seer* (Plate 6). Here, however, only one of the protagonists is a mannequin; the other is the Victorian statue so familiar in de Chirico's early art. Both figures seem to have emerged in somnambulism from the shadowed foreground that presumably was the scene of their dreaming. Between them a canvas-within-the-canvas is placed on an easel. Its blue tone is almost identical to the colour of the sky, but differentiated from the latter by a subtle greenish tint. The picture-within-the-picture includes drawings of various components of de Chirico's early iconography—architecture, a train, a flag, a statue, a landscape, a tower, the legs of the Roman copy of the Hellenistic statue of Ariadne.

The scene of the dream in the background of the painting is reached by a deep, wooden platform. The dream itself is unmistakably of spring. The sudden warmth in which the diminutive background figures have come out to walk and stand, and the restlessness and relief of winter's end are conveyed with a persuasiveness that goes far beyond the limits of traditional realism. The painting reminds us of the painter's avowed intention to record the emotional impact of imagined experience rather than to document external appearances. His example opened the way for Surrealist artists such as Max Ernst, Yves Tanguy, René Magritte, Salvador Dali, and Paul Delvaux, whose debt to de Chirico each has proudly acknowledged. The ambiguous tonal affinity between the sky and the canvas-within-the-canvas reminds one in particular of many pictures by Magritte.

(adapted from Soby, *Soby Collection*, p. 36)

20

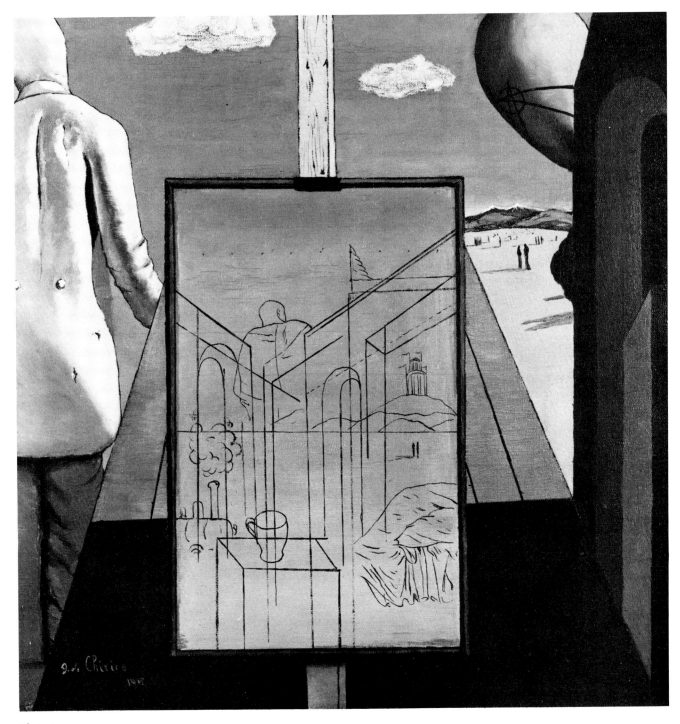

Plate 4

21

The Duo. 1915. Oil on canvas, 81.9 x 59.0 cm. The Museum of Modern Art, New York. The James Thrall Soby Bequest

In *The Duo* the needle-sharp focus of *The Seer* (Plate 6) is relaxed somewhat and the mood is more poignant. Of all of the paintings in de Chirico's 1915 mannequin series, *The Duo* is the most moving and tender. The lovers stand out against their elegiac setting like figures seen through a stereoscope. Behind them a green sky frames a rose tower whose soft colour and bland texture recall the frescoes of the Italian Renaissance artist Piero della Francesca. The artificiality of the potted shrub is conveyed with such acuteness that it appears more real than nature itself.

(adapted from Soby, *Soby Collection*, p. 33)

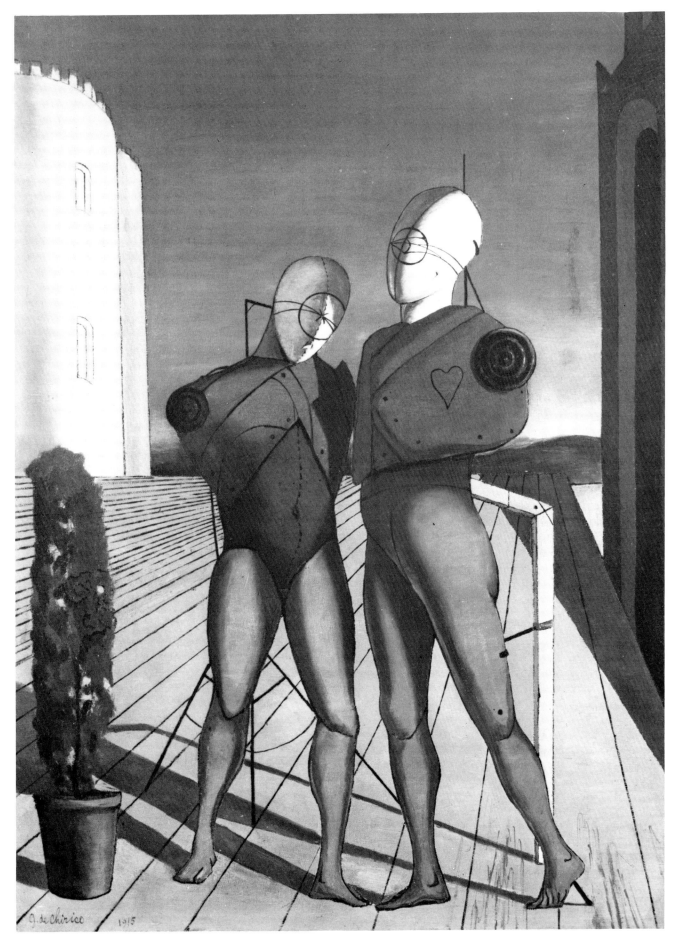

Plate 5

The Seer. 1915. Oil on canvas, 89.8 x 70.0 cm. The Museum of Modern Art, New York. The James Thrall Soby Bequest

The climax of de Chirico's series of mannequin pictures—those in which the figures are armless, stuffed dummies—is reached with *The Seer.* As an image it is the very epitome of the dire, even if warmed by an incalculable poetry of nostalgic mood. Its central figure is depicted as a motionless, brooding presence, perched with wing-like shoulders on a pedestal in front of a blackboard on which appear an architectural drawing, some cryptic letters, the word "Torino" and the outline of a statue. This is the work of an artist convinced of the power of oracles which, as we know from first-hand evidence, de Chirico actually was in his youth.

The setting of *The Seer* appears to be an exterior court or square, bounded in the distance by a toy-like building which may have been inspired by one of the many small, "portable" buildings in Giotto's frescoes. The suggestion seems likely in that de Chirico would certainly have seen Giotto's works in the Church of Santa Croce in Florence. But the ground in front of the building is covered with wooden planking, as in *The Duo* (Plate 5) and *The Double Dream of Spring* (Plate 4). This would seem to imply that the scene takes place indoors. Remembering de Chirico's love of enigmas, it may well be that he used the flooring to convey a sense of uncertainty as to whether a given action occurs within a chamber or in the open air.

The superb mannequin figure dominates *The Seer* through its eloquent strength of contour. Its white head is astonishingly luminous, picking up a greenish reflection from the sky at the left and building up to a blinding white in the centre. Its foil is the intense black of the image on the easel which is held aloft by the strange armatures that were soon to play so important a part in the painter's iconography.

(adapted from Soby, *Soby Collection*, p. 6)

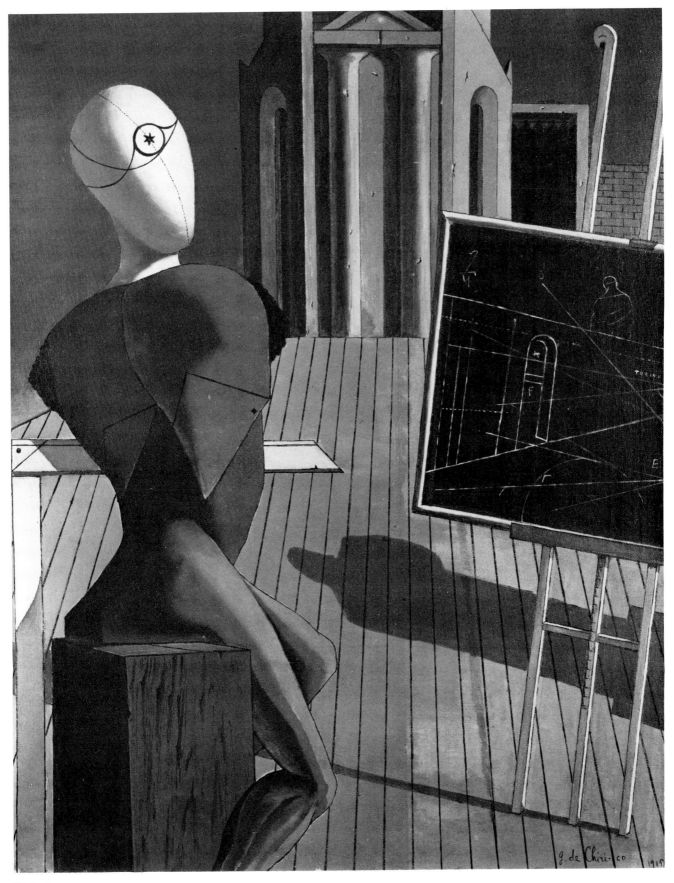

Plate 6

25

Evangelical Still Life. 1916. Oil on canvas, 80.5 x 71.4 cm. The Museum of Modern Art, New York. The Sidney and Harriet Janis Collection

De Chirico's *Evangelical Still Life* was painted in 1916 during his stay in Ferrara. He had left Paris for Italy in the summer of 1915 for military service and entered the 27th Infantry Regiment. When he became ill, he was assigned to a job at headquarters, which allowed him enough free time to begin painting again in the fall.

During his five years in Paris, de Chirico had concentrated on deep perspectives and open squares; but while in Ferrara he concentrated on closed rooms dominated by strange "metaphysical" groupings of real and imagined objects. What struck him above all, he wrote, "was the appearance of certain interiors in Ferrara, certain window displays, certain shops, certain houses, certain quarters, as for instance the old ghetto where one could find candy and cookies in exceedingly strange and metaphysical shapes."

In *Evangelical Still Life*, de Chirico has created an interior that might be the studio of an engineer or a cartographer rather than a painter, judging by the T-square, map, and wooden armature at the right. The ambience was familiar to him as the son of an engineer. He might have seen the cookies and the map while wandering through Ferrara—the former in the ghetto shop windows referred to above, the latter, according to James Thrall Soby, in other store windows where maps were placed to trace the course of World War One. But, in this painting, some of the compositional elements tend to the baroque, with dots here and there evoking the image of an eye.

A pervasive malaise is communicated in *Evangelical Still Life*, as in the outdoor vistas, by the tensions created by the divergent perspectives—the orthogonals leading the eye to different vanishing points. The contours of the two-paintings within the painting are distorted, and the window is seen from far below, cut off by a plane that might be a tabletop. The canvas itself is not a perfect rectangle, reinforcing the sense of "space out of joint" induced by the depicted scene. It is as though de Chirico had come to participate so fully in the strangely tilted world of his art that his fantasy had seeped out into the viewer's world.

De Chirico's paintings derived more strength from Cubism than is commonly realized. The armature at the right resembles the abstract scaffoldings of high Analytical Cubism transformed into a fantasy of studio carpentry—or an anticipation of Dada and Surrealist objects. The meticulously painted map and cookies call to mind textured bits of collage, while the dotted armature components and broad, flat, unmodelled planes suggest the orderly world of Synthetic Cubism turned askew.

In this picture, de Chirico seems to be making several comments about the nature of painting itself. Traditionally, paintings provide a "window" into space. Here, the real window and the unnaturalistically coloured sky are abstracted into geometric pictorial elements, while the two paintings within provide the anticipated landscape views. The two views are somewhat disconcerting, however, for in one, the two Ionic columns (one upside down) are seen only through their shadows; in the second, the landscape is a contour map. In the following years, de Chirico was to expand these curious puns—this illusionism within an illusionist style—in works in which the internal paintings contain standard landscapes with *repoussoirs*, while the surrounding components are radically flattened out toward the picture plane. He seems also to have been obsessed with the quality and juxtaposition of angles through which he could manipulate pictorial space in an ever more complicated manner.

(adapted from Lippard, p. 50)

26

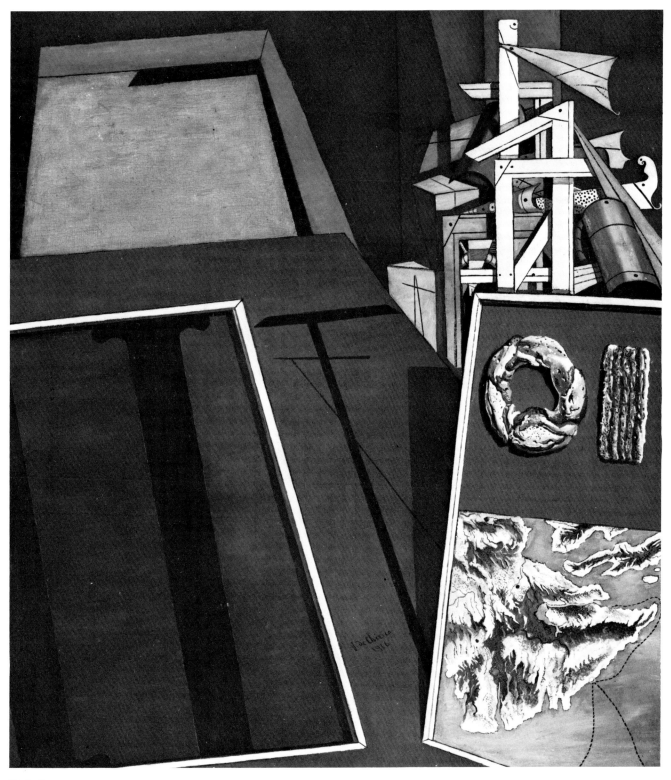

Plate 7

The Amusements of a Young Girl. (1916?). Oil on canvas, 47.5 x 40.5 cm. The Museum of Modern Art, New York. The James Thrall Soby Bequest

One of the most brilliant of de Chirico's works painted in Ferrara is *The Amusements of a Young Girl.* There is little precedent in de Chirico's early art for the Courbet-like solidity of the modelling of the leather glove. Not until 1919 in the famous *The Sacred Fish* (Plate 11) did the artist's technique again become so thoroughly sensuous. Yet there is every reason to believe that the picture was finished at Ferrara, where de Chirico was confined to a military hospital during World War One; its date must be 1916 or 1917, probably the earlier year. The building in the background is obviously Ferrara's red Castello Estense; the box of matches in the foreground is labelled "Ferrara"; the handling of the architecture, the flooring and the board on which the glove is pinned indicates a 1916 or 1917 date. Certainly the picture was completed before the end of the war and long before de Chirico's growing interest in Gustave Courbet prompted him to write a monograph on the nineteenth-century French master (published in 1925). Whatever its exact date, *The Amusements of a Young Girl* is one of the handsomest and most condensed of all the painter's many still-life compositions.

(adapted from Soby, *Soby Collection,* p. 37)

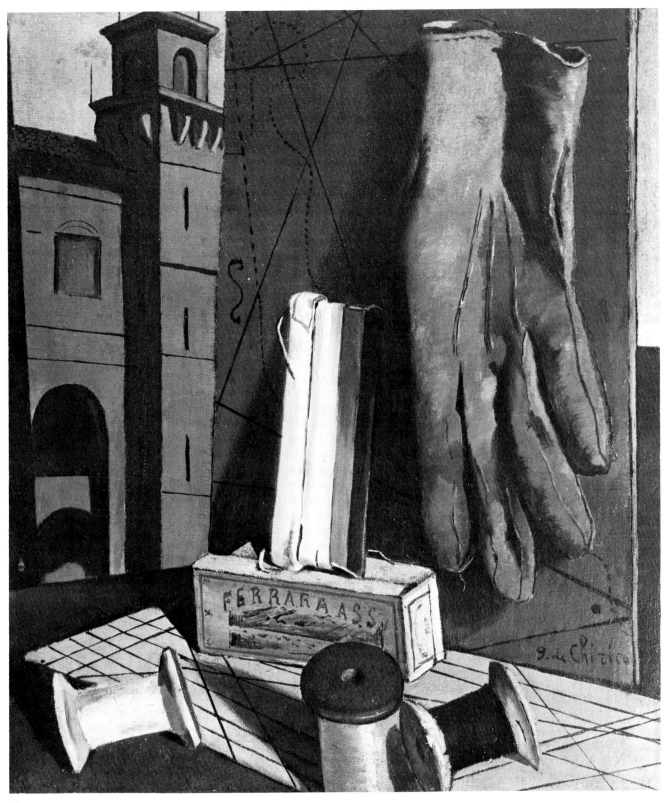

Plate 8

The Faithful Servitor. (1916 or 1917). Oil on canvas, 38.2 x 34.5 cm. The Museum of Modern Art, New York. The James Thrall Soby Bequest

The fact that de Chirico was obliged to spend much of his time during World War One in the military hospital in Ferrara seems to have had an effect on his art. His increasing emotional instability as the tragedy of the war assumed greater proportions is reflected in several still lifes for which the word "claustrophobic" does not seem too strong a description. In *The Faithful Servitor*, for example, there is a new emphasis on forms descending from the top of the pictorial space or crowding in from the sides, as though the artist felt abnormally depressed by his hospital confinement.

It seems possible, too, that the edible objects which appear so often in de Chirico's Ferrara still lifes may have a symbolic significance. Such objects may have represented to his distraught mind the delicacies of civilian life. In *The Faithful Servitor*, the biscuits in their glittering wrappings assume a luxurious tone and texture, as though the painter's longing for the amenities of normal existence had become especially deep.

(adapted from Soby, *Soby Collection*, p. 38)

Plate 9

31

Plate 10 *The Condottiere.* (1917). Graphite pencil, 29.5 x 21.8 cm. The Museum of Modern Art,
New York. The James Thrall Soby Bequest

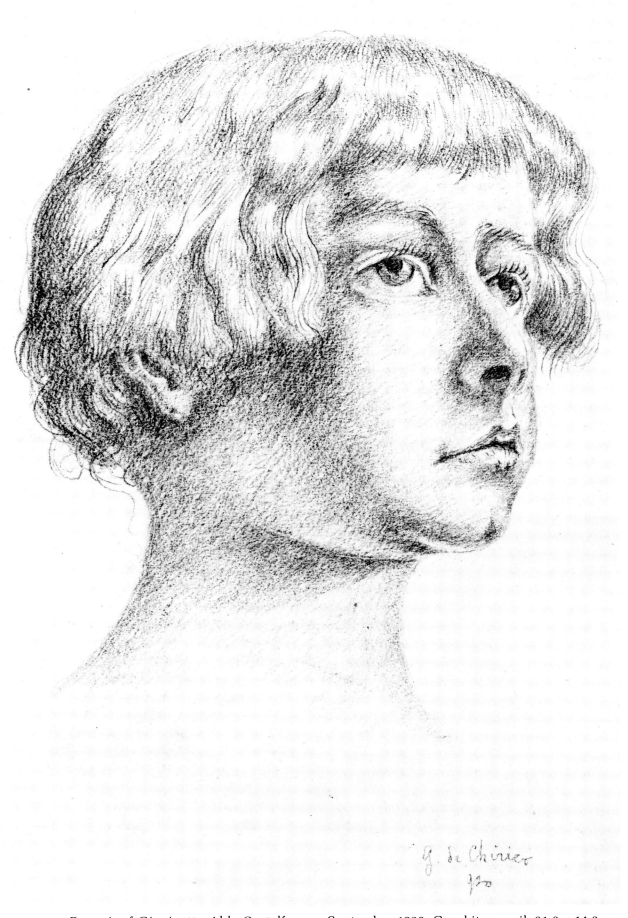

Plate 11 *Portrait of Giovinetto Aldo Castelfranco.* September 1920. Graphite pencil, 21.2 x 14.3 cm.
The Museum of Modern Art, New York. Gift of Mr. and Mrs. Wolfgang Schoenborn in
honour of René d'Harnoncourt

The Sacred Fish. (1919). Oil on canvas, 74.9 x 61.9 cm. The Museum of Modern Art, New York. Acquired through the Lillie P. Bliss Bequest

The most conspicuous technical change that took place in de Chirico's art after his return to Italy in 1915 was a new preoccupation with texture accompanied by a heightened richness of colour. A few of his still lifes of 1919, though less revealing than other works of the psychological upheaval the artist went through after he re-entered civilian life, are of great intrinsic interest and quality in this regard. De Chirico's emphasis on tactile values grew steadily more pronounced until it culminated in the opulent handling of the smoked whitefish or herring in *The Sacred Fish.*

This is the most important of the 1919 still lifes and one of the principal works of de Chirico's entire career. The painting had an immense influence on Max Ernst and other Dadaists in their progress toward Surrealism. For twenty-odd years the picture belonged to Mario Broglio, whose widow's recollections of it, in a letter of October 10, 1950, are well worth recording: "If you examine the medium, it is oily and sombre, like that of the little portrait . . . which is dated 1919. Both paintings evidently were painted in artificial light."

The oiliness and sombreness of *The Sacred Fish* are not the only clues to the fact that it was painted in 1919 and not in 1915 or 1917, as is often published. In composition the picture is closely related to another dated work of 1919—the *Hermetic Melancholy* which was brought to the United States by a partner of Broglio and was subsequently destroyed by fire. Both paintings have a central image—smoked whitefish in one, a plaster head in the other—enclosed by rounded wings, unlike any of the stage-like properties de Chirico had used previously. Both seem to have been painted in artificial light, as Mme. Broglio points out and, as she goes on to say: "In fact in both pictures the 'metaphysical' element, reduced to *coulisse*, gives way to 'after nature'..."

Though *The Sacred Fish* was undoubtedly executed in 1919, after de Chirico's enigmatic vision had begun to be qualified by a rising respect for tradition and technical ingenuity in art, it remains one of the most idiosyncratic and memorable of all his works. Its attraction for fantasists like Ernst is easy to understand. For here, presented in terms of extreme realism, is a pictorial counter-logic based on subconscious sources of inspiration soon to be explored by the Surrealists. The brilliant smoked fish are placed on a platform at the front of a stage and become the protagonists of a strange drama of the inanimate. They are accompanied by unreasonable objects—a toy-like form and a candlestick with a starfish impaled on its wick—so that the known and the impossible are combined to create a believable entity.

(adapted from Soby, *Giorgio de Chirico*, pp. 111, 154, 156)

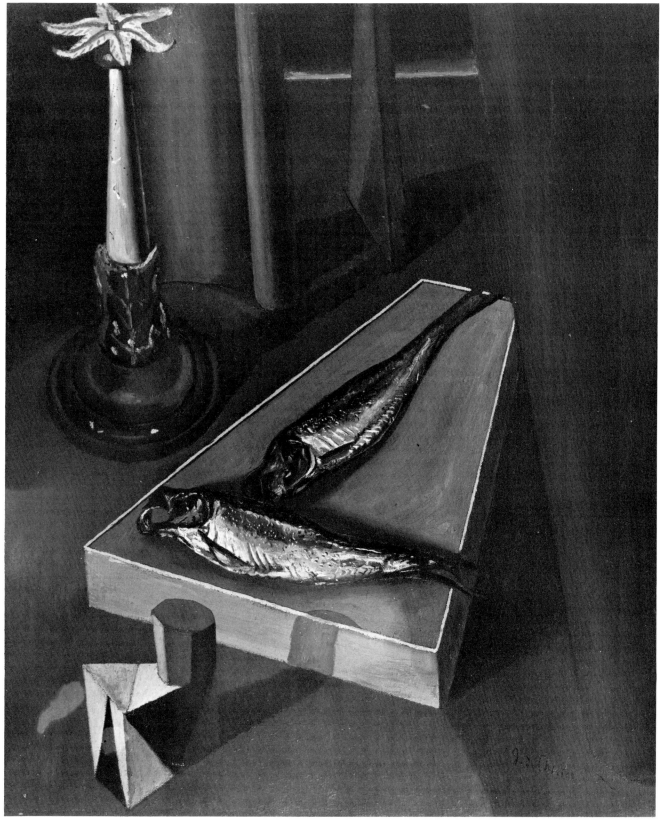

Plate 12

35

Max Ernst

1891
Born April 2 in Brühl, near Cologne, the second of five children of Philippe Ernst, a teacher and painter and his wife, Luise (née Kopp).

1894
First contact with painting—watches his father working on a watercolour.

1896
Makes a series of drawings.

1897
His older sister, Maria, dies.

1906
First contact with the occult, magic, and witchcraft. His pet bird dies the same night his sister is born. These two events become linked in his imagination.

1909
Leaves school and enrolls at the University of Bonn to study philosophy, psychology, and, under Wilhelm Worringer, the history of art.

1910-11
Visits insane asylum and is fascinated with the art of the mentally ill. Interest in Stirner, Nietzsche and artists Arnold Boecklin, Caspar David Friedrich. Forms friendship with August Macke and through him establishes relations with *Der Blaue Reiter* in Munich. Joins *Das Junge Rheinland* which includes, besides Macke, the painters Campendonk, Nauen, the poets Kuhlemann, Henseler, and Otten, a student of Freud.

1912
Visits the Futurist exhibition and the Sonderbund exhibition in Cologne. Views the work of van Gogh, Cézanne, Munch, and Picasso. Decides to become a painter. Exhibits his own work in Friedrich Cohen's bookshop in Bonn (headquarters for *Das Junge Rheinland*) and in the Galerie Feldmann in Cologne.

1913
Meets Guillaume Apollinaire accompanied by Robert Delaunay. First visit to Paris. Participates in the first German Autumn Salon in Berlin with Macke, Wassily Kandinsky, Delaunay, Marc Chagall, and Paul Klee.

1914
First meeting with Hans Arp in Cologne; beginning of a life-long friendship. Despite four years military service as artillery engineer, paints watercolours. Most of these works lost or destroyed.

1916
Der Sturm organizes small one-man exhibition of his work and publishes a drawing on its cover (vol. 6, no. 19/20).

1917
Der Sturm publishes an article by Ernst titled "On the Development of Color".

1918
Returns to Cologne. Marries art historian Louise Strauss.

1919
Visits Munich where he sees works by Giorgio de Chirico reproduced in *Valori Plastici* and meets Klee. Makes his first altered engravings and collages. Begins active collaboration with Alfred Baargeld in the Cologne Dada movement. They publish *Der Ventilator*, banned by the British army of occupation, and show in first Cologne Dada exhibition.

1920
His son, Jimmy, is born. Publishes *Die Schammade* with Baargeld. Renews his

friendship with Arp with whom he collaborates on a number of collages. Participates in final Dada exhibition in Cologne.

1921
At invitation of André Breton, holds first one-man exhibition of collage in Paris at Galerie Au Sans Pareil. Spends the summer in Tarrenz, Tyrol, with Arp, Sophie Taeuber, Tristan Tzara, and, for the last time, Louise Ernst. First meeting with Paul Eluard and his wife Gala in Cologne. Begins series of proto-Surrealist paintings (1921-24).

1922
Second summer in the Tyrol. Moves to Paris suburb Saint-Brice in the autumn. Publishes *Les Malheurs des Immortels* and *Répétitions* in collaboration with Eluard.

1924
Travels with Eluard and Gala for several months in the Far East. Breton publishes *First Surrealist Manifesto*.

1925
Develops *frottage* technique. Participates in first Surrealist group exhibition.

1926
Publishes *frottage* series *Histoire Naturelle*. Collaborates with Joan Miró on the design of sets and costumes for Diaghilev's ballet *Romeo and Juliet*.

1927
Meets and marries Marie-Berthe Aurenche. Develops *grattage* by adapting *frottage* technique to painting.

1929
Publishes the collage novel *La Femme 100 Têtes*. Meets Giacometti. Begins *"Loplop"* series.

1930
Collaborates with Luis Buñuel and Salvador Dali on the film *L'Age d'Or* in which he appears.

1931
First exhibition in the United States at the Julien Levy Gallery, New York.

1934
Spends the summer with Giacometti in Switzerland and makes first sculptures. Publishes *Une Semaine de Bonté*.

1936
Exhibits forty-eight pictures in the exhibition "Fantastic Art, Dada, Surrealism" at The Museum of Modern Art, New York. Separates from Marie-Berthe Aurenche.

1937
Publishes *Au delà de la Peinture*.

1938
Breaks with the Surrealist group. Moves to St. Martin-d'Ardèche, near Avignon with Leonora Carrington, whom he met the previous year. Decorates house with wall paintings and reliefs.

1939-40
Interned in France as an enemy alien; shares room with Hans Bellmer; escapes twice. Adapts *decalcomania* technique.

1941
After many difficulties leaves Europe with Peggy Guggenheim and arrives in New York. Travels through Arizona and California. Marries Peggy Guggenheim; they separate at close of following year.

1943
Spends the summer in Sedona, Arizona, with Dorothea Tanning, whom he met the previous year.

1944
Works on a series of sculptures in Great River, Long Island.

1945
Wins competition for paintings with *The Temptation of St. Anthony* used in the film *Bel Ami*. Eluard organizes Ernst retrospective at the Galerie Denise René, Paris.

1946
Marries Dorothea Tanning. Buys land in Sedona and builds a house.

1948
Becomes United States citizen. Produces monumental sculpture *Capricorn. Beyond Painting* is published.

1949
Sails from New Orleans for Europe where he visits old friends Arp, Eluard, Giacometti.

1950
First post-Second World War retrospective at the Galerie René Drouin, Paris. Returns to Sedona.

1951
Retrospective exhibition in his native town of Brühl.

1952
Tanguy visits Sedona. During summer lectures at the University of Hawaii, Honolulu.

1953
Returns to Paris. Retrospective exhibition at the Municipal Casino, Knokke-Le-Zoute, Belgium. Visits Cologne for the first time in twenty-five years.

1954
Awarded the Grand Prize for painting at the Venice Biennale.

1955
Settles in Huimes near Chinon with Dorothea Tanning.

1956
Retrospective at the Kunsthalle, Bern. Spends winter in Sedona.

1957
Receives the Nordrhein-Westfalen Grand Prize for Art.

1958
Becomes French citizen.

1959
Retrospective at the Musée National d'Art Moderne in Paris.

1960
Travels to Germany with Patrick Waldberg.

1961
Retrospective at The Museum of Modern Art, New York. Retrospective of his sculpture at Le Point Cardinal, Paris. Receives the Stefan Lochner medal from city of Cologne on his seventieth birthday.

1962
Retrospective at the Tate Gallery, London, and the Wallraf-Richartz Museum, Cologne.

1963
Retrospective at the Kunsthaus, Zurich.

1964
Maximilliana ou L'Exercise illégal de l'astronomie is published in Paris. Settles in Seillans in south of France.

1965
Exhibition of new paintings and collages at the Galerie Alexander Iolas, Paris.

1966
Exhibition of sculpture and recent paintings at the Jewish Museum, New York. *Au delà de la Peinture* exhibition at the Palazzo Grassi, Venice.

1967
Comprehensive exhibition of graphic works at Hamburg Kunsthalle.

1969-70
Retrospectives in Stockholm, Amsterdam, and Stuttgart.

1971
Eightieth birthday marked by many exhibitions and festivities including enlarged version of "Inside the Sight" exhibition at the Orangerie des Tuileries, Paris.

1972
Receives Honorary PhD from philosophy department, University of Bonn.

1976
Dies April 1 in Paris.

No artist more completely personified the avant-garde between the two world wars than Max Ernst. In the extraordinary variety of his styles and techniques, he is to Dada and Surrealism what Picasso is to twentieth-century art as a whole. It was primarily in 1919 as a collagist that Ernst discovered himself as an artist, for in collage he could give free rein to his taste for a detailed literal imagery. He used the found collage elements principally for their image value, joining them in irrational and disconcerting ways. Later, from 1921 to 1924, Ernst made large paintings, such as *The Elephant Celebes* of 1921 in which comparable collage elements were painted in *trompe l'oeil*. The simpler, more narrative iconographies and the more illusionistic modelling created a deep dream-like space that anticipated Magritte, Tanguy, and Dali. These pictures, which stand between de Chirico and the younger painters, are best thought of as proto-Surrealist. They combine de Chirico's spatial theatre with ideas derived from Ernst's own Dada collages. *Woman, Old Man and Flower* falls within this mode.

In *Woman, Old Man and Flower*, Ernst maintains the disjunctive quality of collage by combining disparate elements, often on an illogical scale. The tiny woman in the old man's arm creates a disoriented space comparable to that found in the collages. The irrational juxtapositions—the old man; the nude woman; the headless figure crowned with a fan which Ernst designates as the flower; the upright poles, one of which abuts and joins the old man's head; the stony barren landscape—clearly derive from the incongruous and enigmatic conjunctions of Ernst's Dada collages.

Ernst furthered this enigmatic sense by eliminating vital body parts—here exemplified by the removal of the head of the flower figure and the amputated foot and hollowed-out body of the old man—and by combining human and non-human forms as in the semi-animalistic head of the old man and the fan which tops the central image. Hands gesture ambiguously and are all the more mysterious for being transparent. These disturbing associations are drawn from the realm of unconscious dream imagery. Indeed, as with other of Ernst's works, this painting originated in a childhood fantasy. In 1927, only a few years after painting *Woman, Old Man and Flower*, Ernst published for the first time an account of a vision he had in 1897 during a fever.

> I see before me a panel crudely painted with large black strokes on a red background imitating the grain of mahogany and provoking associations of organic forms—a threatening eye, a long nose, the enormous head of a bird with thick black hair, and so forth. In front of the panel a shiny black man makes slow comic and, according to the memories of a time long past, joyously obscene gestures. This odd fellow wears my father's moustaches. After several leaps in slow motion which revolt me, legs spread, knees folded, torso bent, he smiles and takes from his pocket a big crayon made from some soft material which I cannot more precisely describe. He sets to work. Breathing loudly he hastily traces black lines on the imitation mahogany. Quickly he gives it new, surprising and despicable forms. He exaggerates the resemblance to ferocious and vicious animals to such an extent that they become alive, inspiring me with horror and anguish. Satisfied with his art, the man seizes and gathers his creations into a kind of vase which, for this purpose, he paints in the air. He whirls the contents of the vase by moving his crayon faster and faster. The vase ends up by spinning and becomes a top. The crayon becomes a whip. Now I realize that this strange painter is my father. With all his might he wields the whip and accompanies his movements with terrible gasps of breath, blasts from an enormous and enraged locomotive. With a passion that is frantic, he makes the top jump and spin around my bed.

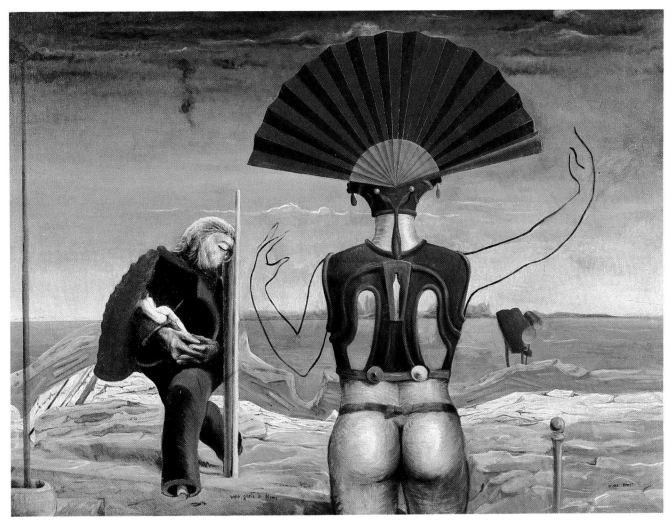

Plate 13

Elements from that vision were taken up in an earlier version of this painting. The father, as Ernst describes him, is on the left with the woman in his arm. Next to him is the spinning top, and in the foreground another nude woman. In 1924 Ernst completely repainted the earlier version retaining only the upright panel, similarities in the pose of the man, and the tiny nude woman.

One decisively important influence for Ernst was de Chirico whose work he saw in 1919 in a booklet of reproductions. De Chirico too had juxtaposed incongruous objects. He was the first to transplant into painting the nineteenth-century poet Lautréamont's paradigm "of the chance encounter of a sewing machine and an umbrella on a dissection table." Through distorted perspective and rearranged scale and space he had created an irrational world removed from accepted reality. Ernst sought to probe the unconscious and produce the dream-like ambiance created by de Chirico. He would frequently allude directly to de Chirico's imagery as he does here with the hollows in the metallic jacket.

Yet even though Ernst was more consistently illusionistic than de Chirico, he still wished to stress the frontality of the picture plane. In *Woman, Old Man and Flower*, he disposes his figures laterally, emphasizing the shape of the canvas by repeating vertical elements within the composition. He combines flat, transparent forms with volumetric figure parts to return the receding background of water and distant land to the picture surface, thereby neutralizing the deep perspective.

L. R. (with adaptation from Rubin, *Dada, Surrealism, and Their Heritage*, pp. 49-50, 82)

Forest and Sun. (1925). Pencil *frottage,* 21.0 x 27.0 cm. The Museum of Modern Art, New York. Gift of Mme. Helena Rubinstein

In 1925, influenced by Breton's Surrealist manifesto, Ernst departed from his more illusionistic work and began the *frottage* (rubbing) drawings. An offshoot of collage, these are his unique contributions to automatism, or abstract Surrealism. Ernst's own description of the origin of *frottage* refers to the evening of August 10, 1925 when, "I was struck by the obsession imposed upon my excited gaze by the wooden floor, the grain of which had been deepened and exposed by countless scrubbings. I decided to explore the hidden symbolism of this obsession, and to aid my meditative and hallucinatory powers, I derived from the floorboards a series of drawings by dropping pieces of paper on them at random and then rubbing them with black lead...The drawings thus obtained steadily lost the character...of the wood, thanks to a series of suggestions and transmutations that occurred to me spontaneously (as in hypnagogic visions), and assumed the aspect of unbelievably clear images probably revealing the original causes of my obsession...

"I marveled at the results and, my curiosity awakened, I was led to examine in the same way all sorts of materials that I happened upon: leaves and their veins, the ragged edges of sackcloth, the palette knife markings on a 'modern' painting, the unwound thread from a spool, and so forth . . .''

With *frottage* Ernst reduced his conscious participation in the creation of his work and could almost view its development as a spectator. However, he realized artistic conception to be a two-fold process and would allow the random patterns formed by the *frottage* procedure to stimulate his imagination, until he consciously altered the accidental configuration.

Forest and Sun is a fine example of *frottage* drawing. The *frottage* which almost covers the entire surface of the sheet, was formed by rubbing a black pencil over paper placed on top of an indiscernable object to transfer the design repeatedly onto the new sheet. The pattern this produced has varying degrees of density and is metamorphosized into natural images. As in Ernst's Dada collages there is little sense of depth. The image is focused on the flat plane. The vertical motif and the wheel image he had employed in earlier work are transformed into the natural forms of the trees and sun. Furthermore, as he would continue to do in subsequent developments and as he had done in the collages, Ernst submerged painterly and illusionistic qualities in those of graphic character and technique. The sun is a mere outline, the trees are a forest of linear telegraph poles. Ernst once indicated the significance of this image when he commented that he ran away from home at the age of five partially "to explore the mystery of telegraph wires which move when you look at them from a running train and stand still when you stand still."

L. R.

Plate 14

43

Ernst was soon to adapt the automatic *frottage* technique to oil paintings with a process he called *grattage*. This involved scraping away layers of paint from the canvas while holding it over textured objects, or pressing paint-dipped wire, rope, or wood onto the canvas to produce a multi-textured, tactile surface. In *Birds above the Forest*, Ernst first coated the painting with a thick layer of white paint through which he ran a plasterer's comb-like tool in waves, completely striating the entire surface with parallel ridges. This provided a unified texture throughout. Once this ridged paint had dried he painted areas of black sky and green tree tops. Layers of paint were then scraped off between the ridges to reveal, in several sections, the white underpainting. By adding colours, with either a dry brush or roller, which in some instances would be scraped again, he designated individual bird forms and tree trunks. This technique of continuously scraping away layers of paint created images composed of subtle variations of colour. With an almost spectral aspect, these forms flicker against the mysterious night scene and are punctuated by one or two bursts of bright colour as in the blue and red heads of the two central figures.

The sensuously textured surface the artist presents us is quite different from the earlier dry paint handling of *Woman, Old Man and Flower* (Plate 13). Yet, as with the proto-Surrealist and *frottage* works, Ernst continues to keep the surface flat. The viewer's unusual vantage point is from above, in the sky, looking down with the birds to the forest below. Although we experience a sensation of height there is none of perspectival depth. The slight sense of recession implied by the tree tops is negated by the overwhelming expanse of dark, unmodelled sky and the enlarged birds that share our space. The lack of modelling, the uniform texture, the heavy pigment, and the merging of colours, all achieved through the scraping technique, reinforce Ernst's emphasis on the picture plane.

In Ernst's work, the innovative technique and creative process went hand in hand with and were dependent on the artist's personal vision. Both the forest and the birds were obsessive images for Ernst. From the time he was three years old, his father had taken him to the forest surrounding Brühl, the town near Cologne where he was born. There the dense foliage obscured the daylight and the forest came to symbolize night, producing both enchantment and panic; paradoxically he was outside and free and at the same time hemmed in and imprisoned by the trees. Ernst never forgot these impressions and echoed them in many of his forest paintings.

Birds also played a role in Ernst's childhood fantasies. The artist describes how, in 1891, "On the second of April at 9:45 a.m. Max Ernst hatched from the egg which his mother had laid in an eagle's nest and over which the bird had brooded for seven years." He recounts that in 1906, "On the night of the fifth of January one of his closest friends, a most intelligent and affectionate pink cockatoo, died. It was a terrible shock to Max when, in the morning, he discovered the dead body and when, at the same moment, the father announced the birth of a sister.

"In his imagination Max coupled these two events and charged the baby with the extinction of the bird's life. There followed a series of mystical crises, fits of hysteria, exaltations and depressions. A dangerous confusion between birds and humans became fixed in his mind and asserted itself in his drawings and paintings." Later, around 1929, Ernst created an alter-ego avian creature named Loplop, Superior of the Birds, with whom he identified and often depicted as resembling himself.

Both bird and forest play a role in the mythology of German Romanticism to which Ernst felt a close affinity. The bird, with its elusive nature and varied colours signified flight, fantasy and intellect; the forest was a primordial place

Plate 15

of shelter and source of life. Hence for Ernst, forest and bird shared dual connotations—birth, revelation, freedom, release of self on the one hand, and death, darkness, fear, containment on the other. Ernst invests *Birds above the Forest* with some of these conflicting emotions. The seemingly endless darkness of the night sky is forbidding, primeval. Several of the birds are reduced to vestiges of bird-body and eye. Yet Ernst conveys freedom with the high viewpoint and resulting sensation of flight, and the enchantment of the ghostly glowing night scene.

L.R.

45

Fleurs-Coquillages (Shell Flowers). 1929. Oil on canvas, 99.8 x 81.0 cm. Museum Ludwig, Cologne

In the same period as the monumental forest paintings of the 1920s, Ernst produced a brilliant set of highly abstract, decorative pictures known as "Shell Flowers." The effect of painterly shells and blossoms was created by *grattage*, around which Ernst painted flat schematic backgrounds in saturated contrasting colours.

(adapted from Rubin, *Dada and Surrealist Art*, p. 184)

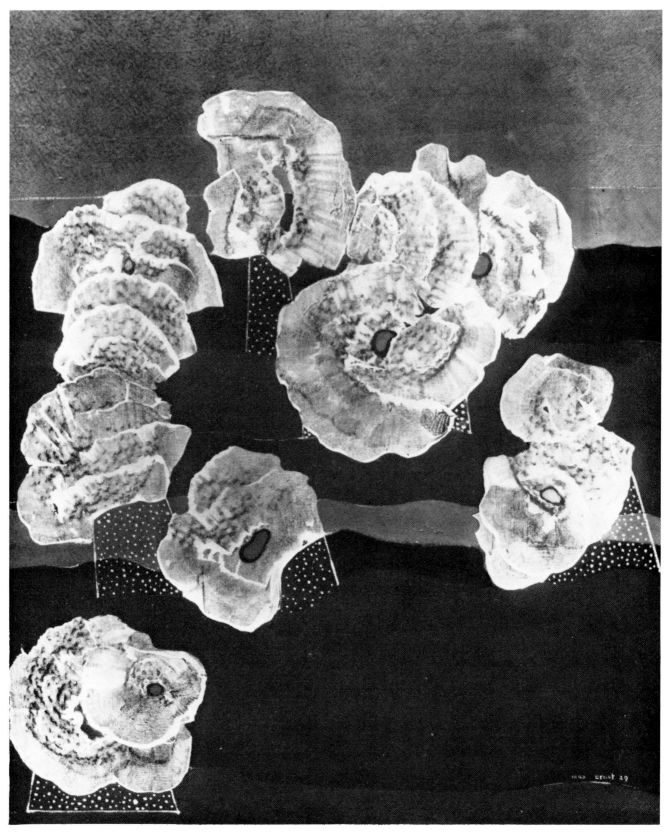

Plate 16

Les Asperges de la Lune (Lunar Asparagus). 1935. Painted bronze (cast 1972), 163.4 cm high, including bronze base 11.6 x 23.0 x 11.6 cm. The Museum of Modern Art, New York. Gift of the artist

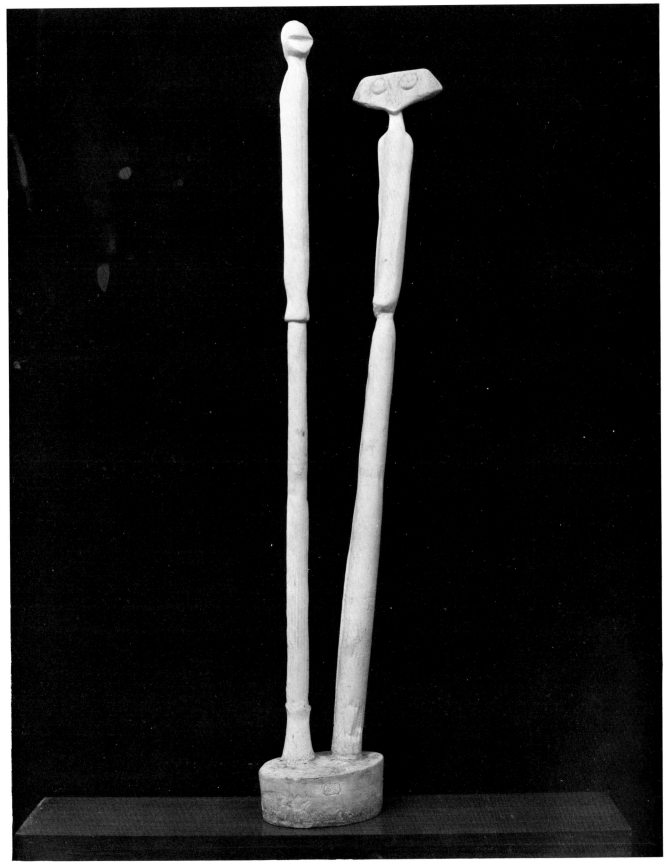

Plate 17

An Anxious Friend. 1944. Bronze (cast 1973), 67.0 x 35.5 x 40.4 cm including bronze base 6.3 x 34.5 x 26.3 cm. The Museum of Modern Art, New York. Gift of the artist

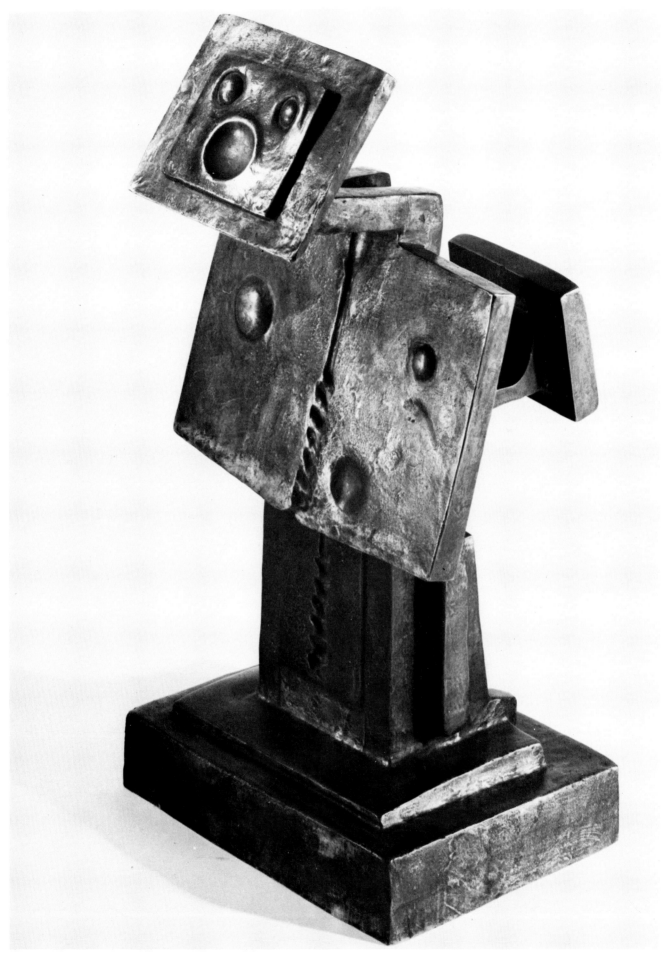

Plate 18

Although Ernst had created some free-standing constructions, assemblages, and reliefs prior to 1934, his career as a serious sculptor began in 1934, when he spent the summer with Alberto Giacometti in Maloja, Switzerland. Inspired by some rounded and polished granite stones found in the Swiss mountain streams, he proceeded to alter these "found objects" either by painting them or incising shallow designs on their surfaces. His next series of sculptures, dating from 1934-35, which include *Lunar Asparagus*, were entirely sculptural. Though seemingly modelled, they were formed by casting in plaster common objects such as milk bottles, flower pots, containers, cylinders, etc. Ernst would then recombine these everyday objects in odd juxtapositions, stressing reversals of shape, asymmetry, and dislocations until their original identity was well disguised or concealed and their forms cohered to a completely new and independent image. In this manner Ernst adapted the automatic techniques of his collages and *frottages* to the execution of sculpture. Ernst also continued to depict the imagery of his two-dimensional works. The new fantastic configurations he produced in sculpture were the same hybrid figures found in the dream imagery of his Surrealist paintings. The staggered, repeated vertical form of *Lunar Asparagus* had appeared earlier. Even his modifications of the Maloja stones were three-dimensional realizations of the oval forms—part egg, part eye— he had previously presented.

Another period of sculptural activity occurred during the summer of 1944, when Ernst rented a house in Great River, Long Island, New York. There he executed approximately a dozen pieces in the garage he had converted into a studio. Like the earlier sculptures, these also were conceived in plaster, and were not cast in bronze until the 1950s and 1960s. Applying the same techniques as before, Ernst continued to develop the hallucinatory images of his two-dimensional works with his sculptured pieces. *An Anxious Friend*, for example, is composed of rectangular planes accented by concave and convex circles, each separate part assembled as if forming a collage. A fantastic creature with two heads, one in the front and a second in the back, both transfixed with anxiety, this sculpture combines whimsy and humour in an ironic spirit that is at once light-hearted and forbidding. A most impressive work from this period is *The King Playing with the Queen*. Inspired by a proposed exhibition on the theme of chess at the Julien Levy Gallery, its central image is a horned male figure which refers to sexual power.

Ernst moves easily back and forth between two- and three-dimensional aspects in other ways: the motif of the incorporation of the sculptural platform as an integral part of the piece was important to Surrealist sculpture and gives the base an essentially pictorial role. In *The King Playing with the Queen* the large figure rises from the table top on which the queen and other figures rest. Also in this 1944 period, and especially in this sculpture, Ernst used the Surrealist device of opposing concave and convex shapes to provide a sense of volume and hollowness. Again, Ernst's interest in hollow and volumetric forms stems from earlier paintings, notably *Woman, Old Man and Flower* (Plate 13).

Ernst's sculpture also reflects his interest in and knowledge of the many styles and varieties of primitive art. He imparted to his sculpture the exoticism and supernatural and emotional qualities characteristic of primitive art, as well as its simple form and implied humour. *An Anxious Friend* exhibits the rectilinear features and compact volumes of the Kachina dolls he collected while in the United States. The hollow forms of *The King Playing with the Queen* drew upon African spoon-sculptures.

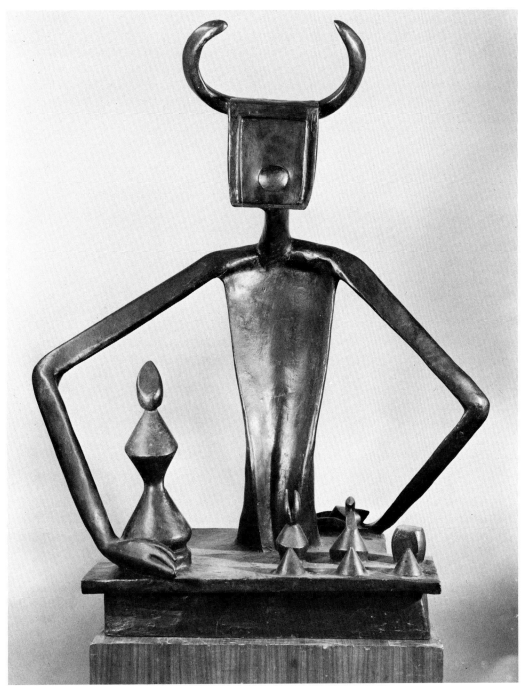

Plate 19
The King Playing with the Queen. (1944). Bronze (cast 1954, from original plaster), 97.8 cm high, at base 47.7 x 52.1 cm. The Museum of Modern Art, New York. Gift of D. and J. de Menil

Linked to Ernst's involvement with primitive art and the natural forms to which it refers was his concern with nature; he indicated its presence in the striated designs he sometimes included in his sculptures, as in the fluting on *Lunar Asparagus*. But for the most part his sculptures rejected texture in favour of smooth surfaces. This presents us with a curious paradox, for one tends to think of sculpture in tactile, plastic terms, whereas it is in his paintings that Ernst employs surface texture. A further contradiction occurs in that he makes use of this texture to stress the picture plane and hence the two-dimensional character of his works.

L. R.

53

The Nymph Echo (La Nymphe Echo). 1936. Oil on canvas, 46.3 x 55.2 cm. The Museum of Modern Art, New York

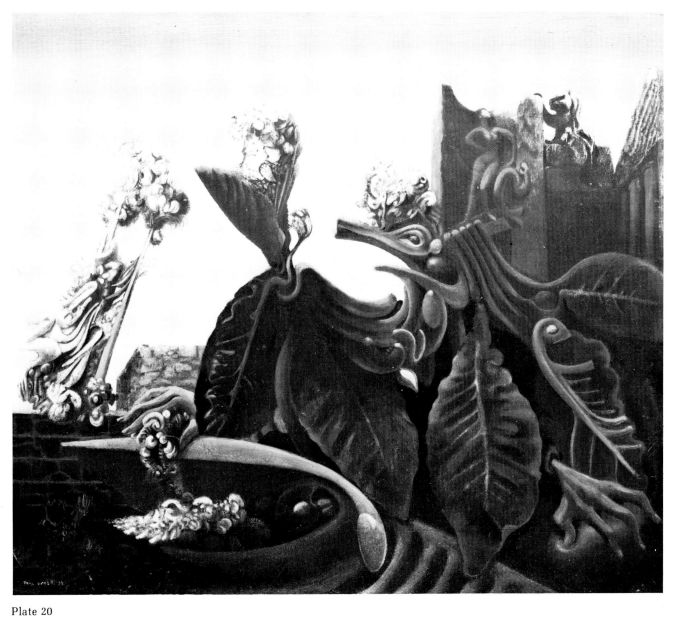

Plate 20

In the mid-1930s Ernst returned to the theme of the timeless and supernatural aspect of nature which he had explored in the forest pictures. Recognizing the disaster toward which Germany and all of Europe was heading, he painted a series of scenes of devastated petrified cities, such as *The Entire City*, where monumental ruins of civilization, the last remnants of life, stand on an acropolis set amidst scattered fragments of vegetation. *The Nymph Echo*, likewise, depicts this universal devastation. Yet, unlike *The Entire City*, the ruins now consist of only a few crumbling walls in the lower left, the rounded alcove in which the nymph stands and the pillared, pedimented portico in the upper right. Instead of presenting the vestiges of vegetation as in *The Entire City*, nature here runs rampant, invading the ruins. The lush, swollen leaves are voracious and predatory, forming variations of the carnivorous Venus Fly Trap. The flora is now anthropomorphized into primitive and bestial forms which have heads and bulbous eyes. Parts of the foliage are egg-shaped, others, like the sprays of flowers on the left, are reminiscent of bony remnants and human organs. Eerily composed of half-hidden insect and animal forms, the garden is alive and lies in wait for its victim.

This sense of menace and entrapment is emphasized stylistically by the recession of the sky and the giant fleshy plants which tumble toward and press down on the viewer. The sickly green colour conveys the poisonous quality which this vegetation emanates. Perhaps the ultimate horror is represented by the two human hands which protrude from either side of this mass of vegetation. One is uncertain whether the hands are engulfed by or directing the movement of the garden.

In his autobiographical notes for 1935 Ernst writes: "Voracious gardens in turn devoured by a vegetation which springs from the debris of trapped airplanes . . . With my eyes I see the nymph Echo."

The trapped airplanes he refers to are depicted in his *Garden Airplane-Traps* series of 1935. The shapes on the left of *The Nymph Echo* (as well as those in the foreground of *The Entire City*) resemble the trapped airplanes. We wonder if the voracious vegetation on the right is not in turn being devoured by these forms. Some of them already crown or sprout from the plant life and seem to breed in the large bowl containing egg shapes in the lower left. Perhaps their pretty colours and fragile forms conceal their true menace. This double echo is reinforced by the confusion between insect, animal, and plant life and by the ambiguous scale between the immense jungle and tiny human figure. Each of these double themes serves to point out the hidden capacity for destruction in nature, and the primordial and bestial side of man evident in the political and social realities of the time.

Ernst was intrigued by the metamorphoses and chameleon-like disguises found in nature. This interest in the deceptive appearance of reality reiterated a predominant theme in German Romanticism: the secrets of the forest. In his recollection of his first contact with painting in 1894, Ernst describes how a watercolour of a hermit seated in a beech forest was both peaceful and menacing partly because, "Each of the countless leaves, stirred by branches of the tree, had been delineated with obsessive solicitude; each seemed endowed with a separate and solitary life." In fact, *The Nymph Echo* alludes to the forest of Ernst's childhood and the conflict found there between human and natural forces.

In *The Nymph Echo* Ernst portrays two of his favourite images—the small seductive female nude and the suggestive hands, both found previously in *Woman, Old Man and Flower* (Plate 13). The hands have been mentioned above. The tiny nymph rests or hides in her niche. Cornered by a snake-shaped tendril, she is about to be discovered by a diminutive but brutal animalistic form.

L. R.

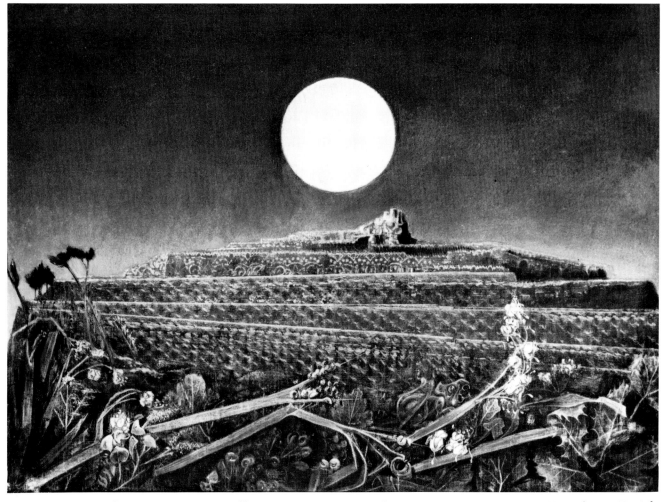

Plate 21 *The Entire City (La Ville Entière)*. 1935-36. Oil on canvas, 60.0 x 80.0 cm. Kunsthaus, Zurich

Napoleon in the Wilderness. (1941). Oil on canvas, 46.3 x 38.1 cm. The Museum of Modern Art, New York

While interned as an alien by the French in 1939, Ernst met Hans Bellmer, with whom he experimented with the painting technique *decalcomania*, a process invented in 1935 by Oscar Dominguez. The technique consisted of squashing areas of wet paint on the canvas with a smooth instrument and then, as Ernst had done with earlier automatic methods, developing the images suggested by the irregular surface. By laying oil paint on the canvas and pressing it with a palette or sheet of glass to manipulate portions of the paint surface, he evoked illusions of exotic foliage, mineral and organic deposits, and spongy growths. In these images the artist found hidden monsters and landscapes which he clarified and elaborated by brush. Whereas Dominguez had used this method with gouache drawings, Ernst applied it to oil painting, a material more suited to *decalcomania* since oil paint produced tighter, more evocative patterns than those Dominguez had produced with gouache.

Ernst used this technique in Europe in 1940 and 1941 and continued to employ it when he arrived in the United States in 1941. *Napoleon in the Wilderness* was the first work he painted in America, although its *decalcomania* base had been begun in France. Only sections of its surface are actually *decalcomania*. The sky, sea, and parts of the figures are painted in a conventional manner; the *decalcomania* is limited to the foreground and the three vertical elements: Napoleon, a totem, and a female holding a fantastic musical instrument. In his notes for 1941 Ernst writes, "He had just quit Europe: Napoleon—the dictator; wilderness—Saint Helena; exile—defeat, and so forth."

The *decalcomania* technique was ideal for indicating the disparity between reality and its appearance, one of Ernst's favourite themes. In *Napoleon in the Wilderness* the bright blue hue of the sky, the smooth nude skin, and luminous turquoise water contrast with the suggestion of soft, spongy, decomposing matter produced by the *decalcomania*. Seething forms of life, reeking of corruption, spring from these ruins and putrefaction. As he had done in *The Nymph Echo* (Plate 20), Ernst fuses human, animal, vegetable, and mineral life. We encounter rotting, swampy vegetation; hollow, bony carcasses; and petrified, calcified formations.

The earthy texture derived from the *decalcomania*, which obliterates the features of the figures and the land, can be interpreted to represent symbolically both man's primitive aspect and a world in the process of total disintegration. In *Napoleon in the Wilderness* this technique complements the subject matter of the painting.

The formations of Ernst's hallucinatory iconography are suggestive of the fantastic forms and vibrant colours of the Arizona landscape, which the artist had not yet seen. In 1946 Ernst moved to Arizona where he found a real counterpart for the visionary landscape of his mind.

L. R.

Plate 22

Maternity is the study for *Surrealism and Painting*, one of Ernst's most important works of 1942, painted while he was in the United States. The painting incorporates several mythical bird-like figures, an image predominant in Ernst's art since the late 1920s. These anthropomorphic creatures are descendents of Loplop, the avian alter-ego whom Ernst had introduced into his work in 1928-29 and who reappears at various times throughout the artist's career. As Ernst clearly noted in writing about 1941, "Loplop, Bird Superior, had followed the airplane which brought me to this country on the fourteenth of July, and the bird builds his nest in a cloud on the East River."

Often, as in a series of collages dating from 1919 to 1932, Loplop was shown in the guise of the painter presenting or introducing various images, usually displayed as other smaller pictures within the overall sheet or canvas. In *Surrealism and Painting* Ernst returns to this earlier format; the bird-artist "paints" a work which is represented within the canvas, its head turned away from the movements of its own hand, perhaps to stress the nature of automatism with its lack of active participation by the artist. To further emphasize the link between himself and this fantastic creature, Ernst portrays several artist's tools beneath the bird family in the painting.

The obscure work that the bird-artist creates in *Surrealism and Painting* is composed of elliptical linear patterns derived from a process called *oscillation*, one of the new automatic techniques or methods of chance that Ernst continued to invent while in the United States. Ernst describes this process, which he employed first in 1942, as follows: "It is a children's game. Attach an empty tin can to a thread a metre or two long, punch a small hole in the bottom, fill the can with paint, liquid enough to flow freely. Let the can swing from the end of the thread over a piece of canvas resting on a flat surface, then change the direction of the can by movements of the hands, arms, shoulder and entire body. Surprising lines thus drip upon the canvas. The play of association then begins."
With *Maternity*, Ernst concentrates on the bird which had for him multiple meanings. It is not so much an alter-image of himself or of intellect, as it is a symbol of maternity and procreation. Since his sister's birth and the death of his pet bird on the same night in 1906, Ernst had mentally linked bird and human, particularly regarding matters of birth and death. His description of his own birth involved bird images, for he tells of hatching from an egg laid in an eagle's nest "over which the bird had brooded for seven years."

Maternity depicts two oversized, boneless bird-people. Although less disturbing than the more convoluted, snake-like beings inhabiting *Surrealism and Painting*, the drawing maintains its sense of mystery and unreality with its dark, brooding background colour, its undifferentiated flowing lines, and the curious shiny, smooth, foetal look of the bird-child.

L. R.

Plate 23

Mundus Est Fabula. 1959. Oil on canvas, 130.1 x 162.5 cm. The Museum of Modern Art, New York. Gift of the artist

During the years he lived in the United States, Ernst used as a painting tool a squeegee, an instrument with a flat rubber blade used to press pigment through a silkscreen. When employed somewhat like a palette knife, the squeegee enabled Ernst to achieve the flowing, all-over patterned backgrounds which became prevalent in his works after 1953.

Following the Second World War, Ernst's paintings underwent a stylistic transformation. Though still involved with his technical concerns, he expressed a new interest in pure, painterly surface. In these late works Ernst breaks the picture plane into facets. The crystallized surface produced is able to suggest a planar depth by evoking the impression of many transparent layers. This delicate faceting and sensuous transparency combine with a wealth of flickering, gleaming colour, often applied in a thick, creamy manner, to enhance the decorative nature of these paintings.

In these works Ernst depicts a new representation of the universe which parallels the development of his new painterly style. Passages of paint still allude to his earlier iconographic motifs and recall his personal animal and foliage forms; but the paintings on the whole approach a diverse yet basically abstract imagery, one which could be said to represent the atomic structure of matter itself or the unified energy of the cosmos. The true subject of these canvases is their non-objective painterly field, rich with surface detail and all-over imagery.

Ernst's depiction of earth and its atmosphere in these late works is frequently extremely volatile. This impression is reinforced stylistically both by the crystallization of the surface to suggest the physical decomposition of matter into its component parts, and by the faceted planes and resulting linear construction that convey a sensation of motion.

In *Mundus Est Fabula* we see how Ernst applied these new interests. While the painting displays images from Ernst's private mythology, the creatures straining against the bonds of the confining polygonal shapes are reminiscent of the insect, bird-like, mineral, and animal forms familiar from earlier works. But we are primarily immersed in the golden orange colour and the brilliant surface glow which flickers against the darker underlayer. This constant opposition of dark to light gives the sensation of continual shifting between concave and convex areas. This impression of shifting planes is reinforced by the faceted background and overlapping polymorphic prismatic shapes which constantly twist and move inside-out. The thin transparent layers of paint establish a motion that slides into infinite depths, anchored only by the static, large central shapes of the opaque sky blue and orange-red areas. In *Mundus Est Fabula* we find ourselves caught up in the origins of a world in which unstable forms begin to coalesce, reminiscent of the period following a volcanic outburst when the lava flow ceases, stratification begins, and a world starts the process of solidification.

L. R.

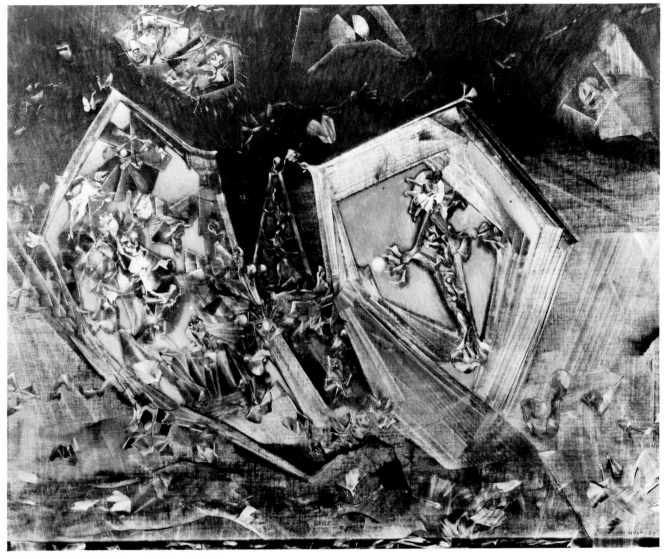

Plate 24

René Magritte

1898
René-Francois-Ghislain Magritte born November 21 in Lessines, a small town in
the province of Hainaut, Belgium, to Leopold, a merchant, and Regina Magritte
(née Bertinchamp). A year later the family moves to nearby Gilly.

1910
Family moves to Chatelet. René and other local children study sketching. Magritte
frequents the old cemetery at Soignies during summer vacations spent with
relatives.

1912
Studies at the Lycée Athénée. His mother commits suicide by drowning herself
in the Sambre River.

1913
Magritte, his father and brothers, Raymond and Paul, settle in Charleroi. Meets
his future wife, Georgette Berger, at a fair. Attends the Athénée.

1916-18
Studies intermittently at the Académie Royale des Beaux-Arts in Brussels.
Receives a brochure on Futurist art and thinks, half-seriously, of becoming an
abstract painter. Magritte family settles permanently in Brussels in 1918.

1918
Begins to associate with young painters, poets, and musicians in Brussels.

1920
First exhibition in Brussels at the Galerie de Centre d'Art.

1922
Marries Georgette. To earn a living, works as a designer of wallpaper, posters,
and advertisements. Paints on his own and experiments with Victor Servranckx
in abstraction. Is shown a reproduction of Giorgio de Chirico's 1914 painting *The
Song of Love,* which changes his conception of what painting *might* be. His
paintings are influenced by Cubism, Futurism, and abstract art.

1924
Allied with Camille Goemans, E. L. T. Mesens, Marcel Lecomte and, slightly later,
Paul Nouge, in activity parallel to that of the Parisian Surrealists. Contributes a
statement to the Dada review *391* (no. 19). Paints what he considers to be his
first serious picture.

1925-26
With Mesens, publishes first and only issue of magazine *Oesophage.* Encouraged
by the security of a contract with the new Galerie Le Centaure in Brussels,
produces a large body of work, including *The Lost Jockey,* 1926.

1927
First one-man show at Galerie Le Centaure is unfavourably received by critics.
Moves in August to Paris suburb Perreux-sur-Marne. Is closely associated with
the Parisian Surrealists, especially André Breton and Paul Eluard.

1929
Publishes *Words and Images.* Visits Salvador Dali in Cadaques, Spain.

1930
Somewhat weary of the polemical atmosphere in Parisian art circles, returns to
Brussels where, except for occasional visits to France, Holland, and England, he
remains for the rest of his life. Resumes old friendships with artists and writers
in Brussels. Among new associates are Louis Scutenaire, Paul Colinet and Marcel
Mariën.

1936
First one-man exhibition in the United States at Julien Levy Gallery, New York.

1937
Stays for three weeks in London at the home of Edward James.

1930-40
Represented in all important international exhibitions of Surrealist art. Writes numerous articles and short statements in which he elucidates his ideas about art and its potential.

1940
Joins the exodus of Belgians following the German invasion of May 19. Spends three months in Carcassonne, France, before returning to Georgette in Brussels.

1940-46
In spite of the grim austerity of living conditions in wartime Belgium, his palette takes on the brilliance of sunlight. For a period he borrows the technique of the Impressionists, especially Renoir, but abandons the experiment when it is badly received by both friends and detractors.

1945
Joins and then abandons the Communist Party.

1948
For several months prepares for his forthcoming exhibition in Paris at the Galerie du Faubourg by reviving the audacious style of the Fauves. The artist himself refers to this brief period as "l'epoque vache." Soon reverts to the precise and painstaking technique, based in part on the early Flemish masters, which he previously had developed.

1949
First exhibition at Alexander Iolas Gallery in New York. Thereafter, Iolas galleries in Paris and Geneva also represent him.

1953
Commissioned by Gustave Nellens, Director of the Municipal Casino at Knokke-Le-Zoute on the North Sea, to design a series of eight themes for murals in the grand salon. The actual murals are executed by Raymond Art and his assistants.

1954
Retrospective at the Palais des Beaux-Arts, Brussels.

1956
Awarded the Guggenheim Prize for Belgium.

1957
Mural in the Palais des Beaux-Arts at Charleroi, based on his painting *Le Fée ignorante*, is executed under his supervision.

1960
First retrospective exhibition in the United States at the Dallas Museum for Contemporary Arts and the Museum of Fine Arts, Houston.

1961
Mural in the Palais des Congrès, Brussels, based on his painting *Les Barricades mystérieuses*, is executed under his supervision.

1962
Exhibition at the Walker Art Center, Minneapolis.

1965
Retrospective at The Museum of Modern Art, New York. With Georgette visits the United States for the first time. Visits Edgar Allan Poe's house.

1966
Visits Israel with Georgette.

1967
Dies August 15 in Brussels. Exhibitions at the Museum Boymans-van Beuningen,
Rotterdam, and the Moderna Museet, Stockholm.

1969
Retrospective exhibitions at the Tate Gallery, London, The Kestner-Gesellschaft,
Hanover, and the Kunsthaus, Zurich.

1971
Exhibition at the National Museum of Modern Art, Tokyo; exhibition travels
to the National Museum of Modern Art, Kyoto.

1973-78
Important exhibitions in London (1973), Houston (1976) and Paris and Brussels
(1978).

The Menaced Assassin (L'Assassin menacé). (1926). Oil on canvas, 150.4 x 195.2 cm. The Museum of Modern Art, New York. Kay Sage Tanguy Fund

Although he had been painting since the early 1920s, it was not until 1926, with the large painting *The Menaced Assassin*, that Magritte's idiosyncratic personality was fully asserted. The script of *The Menaced Assassin* seems relatively clear. A nude woman lies bleeding from the mouth on a sofa in the background. Her murderer calms his nerves by listening to a gramophone, not yet aware that his exit is blocked from the rear by three men peering over the railing at the window and in the foreground by captors who await him with bludgeon and net. The triple extension of perspective—from foyer to living room to distant landscape—reflects Magritte's continuing respect for Giorgio de Chirico's extreme manipulations of space. But *The Menaced Assassin* has its own prophetic overtones. It foretells the somnambulant irrationality of certain figures in sculpture by Alberto Giacometti and in paintings by Balthus, whom Magritte is said to have admired greatly.

(adapted from Soby, *Magritte*, p. 9)

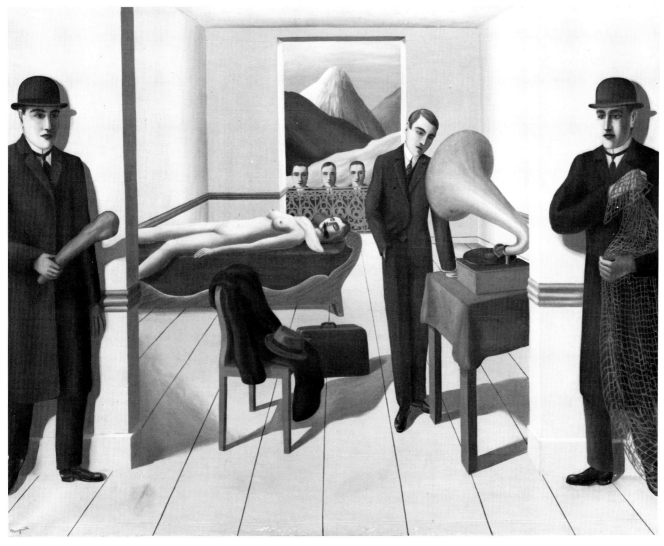

Plate 25

The Palace of Curtains, III (Le Palais des rideaux). (1928-29). Oil on canvas, 81.2 x 116.4 cm. The Museum of Modern Art, New York. The Sidney and Harriet Janis Collection

Magritte painted *The Palace of Curtains, III* in Paris during his only extended sojourn—from 1927 to 1930—outside his native Belgium. In Brussels he had been co-founder of a Surrealist group whose activities paralleled those of their Paris counterparts. While in Paris, Magritte was closely associated with leading Surrealists, notably André Breton, author of the 1924 Surrealist Manifesto, and Paul Eluard. At a time when Surrealist painting was totally dominated by automatism, in keeping with the manifesto, Magritte renewed the "dream-image" illusionism that had been explored earlier by Giorgio de Chirico. The work of that artist, which Magritte first encountered in reproduction in 1922, greatly impressed him and, together with the collages of Max Ernst, became a prime influence on his development.

The picture-within-a-picture device in *The Palace of Curtains, III* is a legacy from de Chirico, but Magritte uses it in a way that is at once milder and more abstract. Typical of his own style, and quite different from that of de Chirico, are the shallow space and frontality of the composition, as well as the meticulous illusionistic finish. Also characteristic of Magritte is the incorporation into the painting of a word as if it were an object. Throughout his career, Magritte was preoccupied with the encounter of words, images, and meanings. In 1954 the Sidney Janis Gallery presented a group of his paintings of 1928-29 taking the exhibition's sub-title, "Word vs Image" from the title of an article Magritte had written in 1929, which was translated and reprinted in the show's catalogue. In this essay, Magritte offered some axioms: "In a painting the words are of the same substance as the images . . . Any shape may replace the image of an object . . . An object never performs the same office as its name or as its image." He always insisted that to equate his painting with symbolism, conscious or unconscious, was to ignore its true nature; for symbolism would imply a supremacy of the invisible over the visible, whereas the latter was rich enough to form a poetic language evocative of both realms. "My paintings," he declared, "have no reducible meaning: they *are* a meaning." In a similar vein, the titles of his pictures are poetic in themselves but usually lack any specific association with the image represented; thus, two other paintings with the title *The Palace of Curtains* bear little if any visual resemblance to this one. More closely related is *The Empty Mask* of 1928 in which an irregularly shaped frame set before the wall of a room is divided into four compartments, the upper left one containing the French word for sky, as in this picture.

The sky is a frequent motif in Magritte's paintings. It is almost always depicted in some disquieting context that confuses the "real" painted sky with a representation of it (often framed), the vaporous with the solid, exterior with interior, or day with night. *The Empire of Light, II* of 1950 (Plate 29) for instance, shows a nocturnal street scene with buildings illuminated by artificial light, set below a bright, cloud-filled daytime sky.

(adapted from Lippard, p. 56)

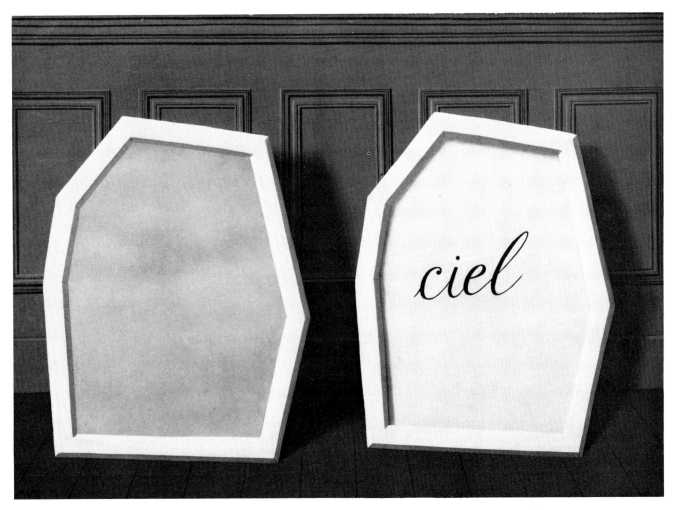

Plate 26

Magritte stressed that an image—the representation of an object that has been painted on a flat surface—was a symbol and not the same as the tangible object itself. In fact a painted image which might delight us could prove uninteresting if we were to encounter the object in reality, and vice versa. Furthermore, any relation between the object and its name exists through a purely arbitrary correlation.

In *This is Not a Pipe*, Magritte explores the different meanings provided by an object, its image, and its name. A representation of a pipe is situated in an undefined space together with an inscription. The legend "This is not a pipe" enables the viewer to logically conclude that this indeed is not a pipe but a painting, and therefore something other than the objective reality it represents. Even though realistically painted in Magritte's meticulous style, the painted pipe could not be substituted for an actual pipe. Thus we understand that this is an image of a pipe, and not the real object (it cannot be smoked); nor does the painted pipe have the same qualities as the word "pipe". There is nothing pipe-like about the word "pipe".

L. R.

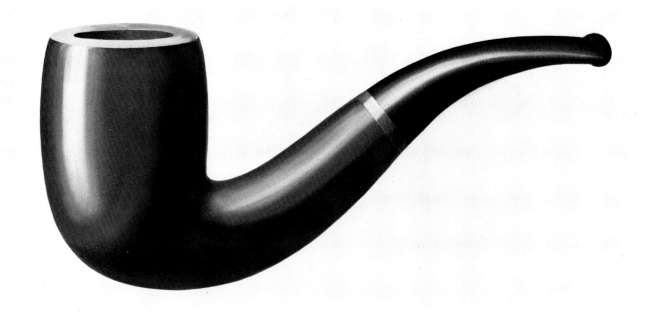

Ceci n'est pas une pipe.

Magritte

Plate 27

The most important single event of Magritte's career took place in 1922 when a life-long friend, Marcel Lecomte, whose likeness in stone appears in *Memory of a Voyage* (Plate 31), showed him a reproduction of Giorgio de Chirico's 1914 painting *The Song of Love.* The picture's impact on the young Magritte was overwhelming. According to his own account, it moved him to tears.

"It was in fact in 1922," Magritte commented, "when I first came to know the works of Chirico. A friend then showed me a reproduction of his painting *The Song of Love,* which I always consider to be a work by the greatest painter of our time in the sense that it deals with poetry's ascendancy over painting and the various manners of painting. Chirico was the first to dream of *what must be painted* and not *how to paint.*"[1]

Both de Chirico and Max Ernst, whose art also was a major influence on Magritte, combined objects in an enigmatic, irrational fashion which effectively revealed hidden affinities that existed between them and endowed them with poetic mystery.

In *Eternity,* Magritte portrays a museum scene in which two bronze sculptured heads of Christ and Dante are placed on pedestals and stanchioned off by a red cord hung on copper supports. Juxtaposed to the representations of these two famous historical figures Magritte exhibited on the third and central pedestal a monumental, cylindrical lump of butter. The butter, into which a wooden spatula has been stuck, is numbered, as are the two flanking exhibits, and each is given equal importance. In this manner Magritte employed de Chirico's use of disconcerting dislocations to challenge and make ludicrous a particular form of culture: works of art as they are exhibited in a museum. "Perhaps more consistently than any other painter of his generation," wrote James Thrall Soby, "he has sought what Guillaume Apollinaire called art's greatest potential— surprise. Magritte tells jokes and invents puns in a quiet voice. Many of us listen with avid attention and our number is growing."[2]

Magritte's allusion to de Chirico in *Eternity* is also expressed more superficially. The rendering of sculptured heads is reminiscent of de Chirico's *Song of Love,* where the antique head of the *Apollo Belvedere* is similarly placed in an architectural setting. And he recalls de Chirico in other ways. One involves the analogous use of a theatrical, exaggerated manipulation of space. In *Eternity* the illusionistically painted pedestals are squeezed into a shallow, stage-like space defined by the wood-grained floor boards, a perspectival device employed earlier in *The Menaced Assassin* (Plate 25). Compressed between the wall and stanchions, the sculptures seem somewhat unsteady.

All of the images in *Eternity*—the heads, the butter, the cord, etc.—are handled meticulously with a careful definition and hard finish that recalls the paintings of the Flemish old masters of Magritte's native Belgium. Through this deliberate realism Magritte created a resemblance that renewed the "dream image" illusionism of de Chirico. Yet paradoxically, and in a manner which again indicates de Chirico's influence, Magritte's lack of tonal subtleties, his generalized shading, and ungraduated modelling produced an impression of abstraction comparable to that of his exemplar.

The shape and colour of the butter effectively reminds the viewer of marble or stone before it has been carved. This impression is reinforced by the spatula, which doubles in the mind as an artist's tool. The sense of a sculpture, not yet formed, but hidden within a clumsy exterior, correlates with Magritte's interest in the visible world. Magritte frequently stated the invisible is but the visible hidden.

74

Plate 28

The idea for this painting seems to have occurred in the early 1930s during a conversation between Claude Spaak and the artist. Spaak had suggested to Paul Delvaux and Magritte that they each paint a scene in the Louvre of two paintings framing a ham. Delvaux thought this project was too surrealistic and declined, but Magritte painted *Eternity*.[3]

L. R.

1. James Thrall Soby, *Rene Magritte*. The Museum of Modern Art, New York, 1965, pp. 7-8. Magritte may have been shown de Chirico's work by the poet and art dealer E. L. T. Mesens, and not by Lecomte. Cf Hammacher, *Magritte*
2. Ibid., p. 11.
3. Related in the catalogue of the exhibition *Magritte-Delvaux-Gnoli* organized by the French Government at the Maison de la Culture, de Bourges, June 17—October 8, 1972

75

The Empire of Light, II (L'Empire des lumières, II). 1950. Oil on canvas, 78.8 x 99.1 cm. The Museum of Modern Art, New York. Gift of D. and J. de Menil

Around 1950 Magritte began to paint street scenes in which houses and pavements are set in darkness relieved only by artificial lights. But the skies above blaze in the noon sun or are illumined by stars and the moon to create an incredible brightness. Magritte himself has had this to say on the subject: "An inspired thought which resembles the visible thing offered to it becomes what was offered to it and evokes its mystery. An inspired thought combines what is offered to it in an order evocative of mystery. For example: it combines a nocturnal landscape and a starry sky (my picture 'The Empire of Light'). A thought limited to similarities can only contemplate a starry sky with a nocturnal landscape. An inspired thought which evoked the mystery of a visible thing can be described by painting: indeed, it consists *uniquely* of visible things: skies, trees, people, solids, inscriptions, etc."

The last sentence in this statement elucidates Magritte's idiosyncratic use of a favourite Surrealist device—the double image. He does not conceal one object or scene within another of different identity, as artists have done since the time of Arcimboldo and as picture-puzzle books customarily do. Rather, he portrays these objects and scenes as self-sufficient and crystal clear, and then questions our capacity to believe by opposing factual statements. In *The Empire of Light, II* we cannot be sure whether to turn on the street lights, to contemplate the stars or, as seems much more likely, to bask in the sun.

(adapted from Soby, *Magritte*, p. 18)

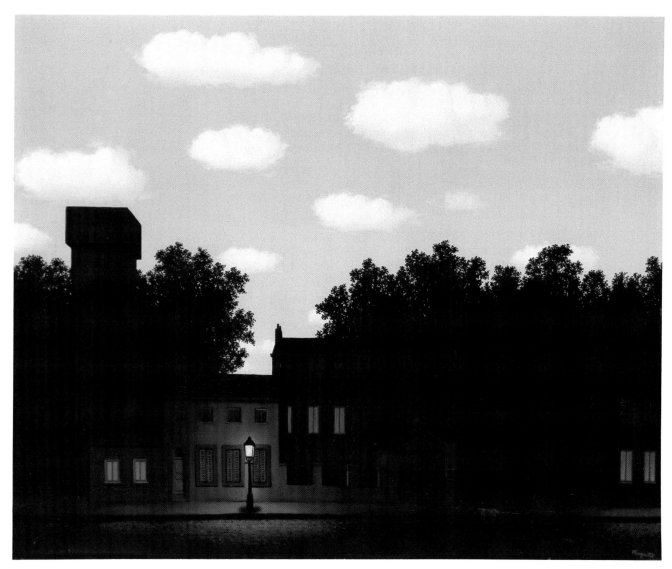

Plate 29

Le Grand Style. 1951. Oil on canvas, 80.0 x 60.2 cm. Menil Foundation Collection, Houston

Several of Magritte's characteristic motifs are presented in *Le Grand Style.* One involves combining seemingly unrelated objects not only to engender a sense of mystery but to allow the viewer to question what is usually taken for granted. *Le Grand Style* depicts a vine or bush. It is not crowned with a rose, as one would expect, but with a planet. Made aware of the physical contradiction inherent in a weighty globe being supported by a fragile vine, the viewer is left to wonder why the world should be supported at all.

In an insightful observation about the artist, the art historian David Sylvester wrote, "Magritte presents dreamlike images as experiences not messages. He evokes extreme or impossible physiological states or events which have an intense affective import—being crowded, being trapped, being immobilized, defying gravity, etc.—with great immediacy but no sensuous correlative, just as in dreams the action is all in one's head...the drama is impersonal: the suspension of gravity: the suspension of time. It induces a nameless terror like the instinctive dread felt during a total eclipse."[1] Magritte himself wrote about the impossible physiological states that he represents in his works. "If the spectator finds that my paintings are a kind of defiance to 'common sense' he realizes something obvious. I want nevertheless to add that, for me, the world is a defiance to common sense. Also I need *nearly ordinary* ideas and feelings to be able to perceive reality. For example: I can have a feeling of sympathy for a stone, or I can have the idea that the creation of the world does not imply a creator, etc...

"My habits of thinking allow me therefore to imagine a painting which represents a standing personage with, for the accompanying inscription, 'seated personage' or other paintings for which the application of common sense becomes an error of appreciation. One must not think, like a blind mechanical tool, that this is concerned with 'nonsense.' My paintings have no reducible meaning: they *are* a meaning."[2]

Disparity of scale is another favourite theme that is well illustrated in *Le Grand Style.* We cannot be sure whether the planet is diminutive or the vine gargantuan. However, in either case we experience a suffocating sensation of fear. By altering the normal proportions of objects, Magritte releases us from the confines demanded by conventional representation and we are able to consider these elements in a manner different than the traditional one.

The technique of scale dissociation is directly derived from collage, in which images borrowed from sources of variant scales are juxtaposed in a disconcerting, irrational manner. Ernst used the technique successfully in his collages and transplanted its irrational quality to his proto-Surrealist works in which he painted collage-engendered elements in *trompe l'oeil.* His *Woman, Old Man and Flower* (Plate 13), where the tiny woman is held in the old man's arm, presents a situation comparable to that of Magritte's *Le Grand Style.*

L. R.

1. David Sylvester, *Magritte.* New York: Frederick A. Praeger, Inc., 1969, p. 1
2. René Magritte. "Les mots et les images." *La revolution surrealiste,* v. 5, no. 12: 32-33, Dec. 15, 1929. English translation by E. L. T. Mesens in the catalogue of the exhibition "Magritte: Word vs Image" at Sidney Janis Gallery, New York, 1954.

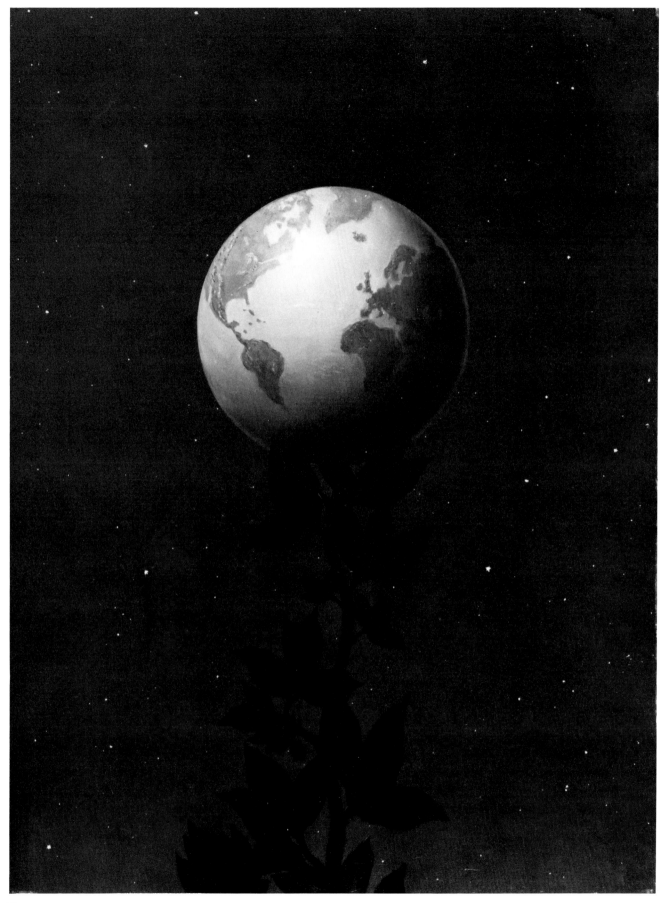

Plate 30

Memory of a Voyage (Souvenir de Voyage). 1955. Oil on canvas, 162.2 x 130.2 cm. The Museum of Modern Art, New York. Gift of D. and J. de Menil

The granite monuments of the old cemetery at Soignies, which Magritte often visited as a youth, recur frequently in his art. As well, he applies the process of calcification to several subjects. In *Memory of a Voyage*, Magritte's friend, the Belgian poet Marcel Lecomte, appears quite literally petrified in his Chesterfield coat. Beside him lies the Androclean lion that often appears in Magritte's later works. It would be tempting to see the lion as a symbol of reformed ferocity except that the artist has repeatedly disclaimed any interest in symbolism. "Sometimes I hate symbols," he once confessed to a reporter for *Time* magazine. He wishes his paintings to say what they say and nothing more. Magritte's art is direct rather than allusive and herein lies its hypnotic charm.

(adapted from Soby, *Magritte*, pp. 16-17)

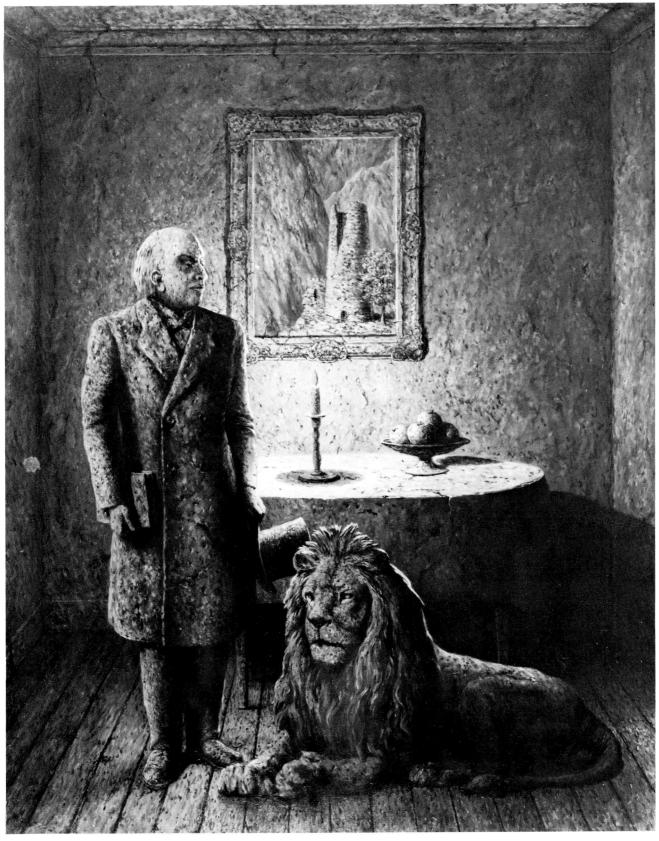

Plate 31

81

The Hole in the Wall. 1956. Oil on canvas, 100.3 x 80.3 cm. Private collection, Caracas, Venezuela

The giant boulder is a ubiquitous image in Magritte's art. Sometimes it looms at the summit of a gorge; at others it drifts in mid-air, increasing an awareness of its great weight. The scenes containing these forms range from enormous panoramas to the enclosed spaces of small rooms. In *The Hole in the Wall*, the massive rock is perched on a wooden floor and jammed into an unrealistically narrow space. The unusual position and the strange surroundings make it clear that this is no ordinary rock; it seems both monumental and mysterious. Magritte evoked the great poetic power of the boulders through a treatment of light that delineates the monumentality of their looming forms. But notwithstanding the feeling of unease created by the painting's shallow foreground, the luminous and spacious sky and sea combine with the imposing rock to produce a sensation of calm and peace.

Magritte's concern was not only with iconography. Subtle blends of tone and light, the contrasts of massive solids with voids, and an abstractness reminiscent of de Chirico all enhance the aesthetic effect of the painting. In his history of Dada and Surrealist art, William Rubin comments that "the effect of compositional—as distinguished from iconographic—factors on the quality of Magritte's art can be gauged by comparing different versions he has made of the same iconographic idea. I refer here to his variants, not his replicas. In these variants, despite little or no change in iconography, we find a considerable range in the impact of the pictures resulting from purely compositional differences."[1]

L. R.

1. William S. Rubin, *Dada and Surrealist Art.* New York: Harry N. Abrams, Inc., 1968, p. 208

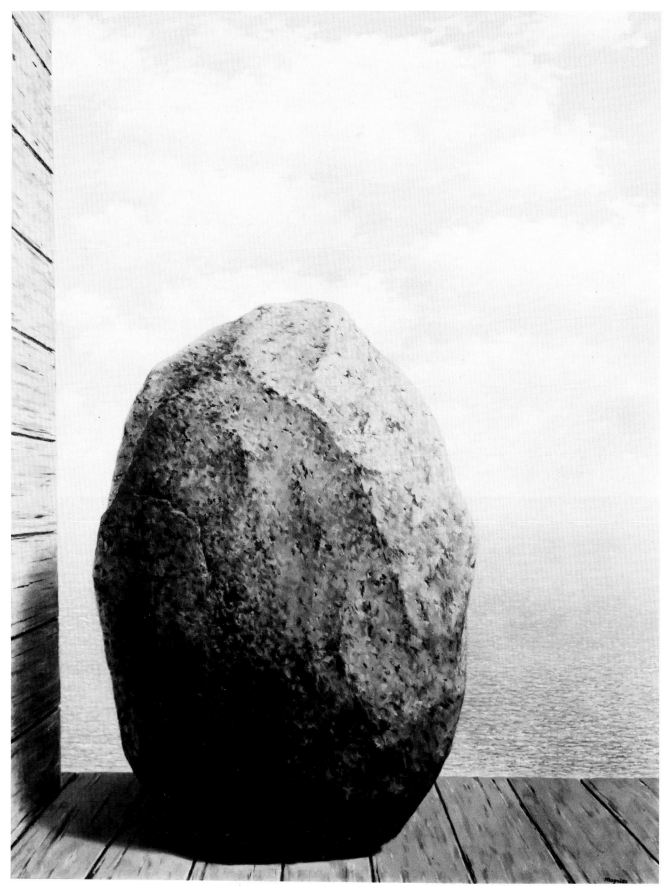

Plate 32

83

La Force des Choses (The Power of Things). 1958. Oil on canvas, 49.8 x 59.7 cm. Menil Foundation Collection, Houston

Magritte frequently altered the behaviour of matter, specifically with regard to the laws of gravity. In *The Power of Things*, he sets a still life afloat in the firmament. As in the paintings of boulders, the refutation of gravity's power had always fascinated him. In this painting, however, the granite is confined to a window sill and it is a loaf of bread and a glass of water that inhabit the sky. By confronting us with objects in mid-air, Magritte forces us to ask why the objects do not fall. By confronting our everyday acceptance of the force of gravity, he makes us realize its awesome power. By making us aware of what a thing is not, he enhances our sense of what it is.

Magritte evokes this mysterious reality by employing banal, ordinary objects so familiar they are almost invisible. Then a single contradictory detail in their presentation rejects everyday reality and brings the images to life. Thus, by using a highly realistic technique to depict commonplace things, Magritte makes the imaginary look real. Moreover, he drew not on the images of dreams and fantasies but on the rich imagery of the visible world.

William Rubin has observed that Magritte "sought an almost total prosaism in the things he represented; his art contains few of the bizarre beings of Ernst, none of the 'paranoid' fantasies of Dali...In his greater closeness to de Chirico, Magritte distinguishes himself from the other Surrealists by the technical devices—*frottage*—and aesthetic formulation—biomorphism—he eschews. In an attempt to create a purely poetic image, he sought to by-pass modernist painting, though the handsomeness and economy of his compositions recall his apprenticeship as an abstractionist. The originality of his images—though not the measure of their pictorial quality—lies in the secret affinities between dissociated objects revealed by means of Lautréamont's poetic principle."[1]

Compositional factors played a large role in the pictorial quality of Magritte's images as well. By altering the image of *The Power of Things* to present many loaves instead of only one, as Magritte did, for example, in *The Golden Legend*, the artist could suddenly change a scene of levitation from one that induced a sensation of peaceable floating to one of oppression and claustrophobia, as if the zeppelin-like loaves had become a menacing new form of life.

In *The Power of Things*, Magritte confronts the viewer so directly and powerfully with the bread and glass of water (or is it wine?) that it would appear the image has a religious significance. Yet as Magritte shunned symbols, he was hostile to psychoanalysis and interpretation. He wished his paintings to say nothing more than what they said, and believed further interpretation denied the mystery of the visible. He stated his opinion on this subject forcefully: "To try to interpret an image of resemblance—so as to exercise, upon it, who knows what liberty—is to misunderstand the inspired image, putting in its place a gratuitous interpretation that, in turn, can serve as the object of an endless series of superfluous interpretations."[2]

David Sylvester describes how Magritte successfully translated these beliefs into painting in his observation that Magritte paints "with a conspicuous absence of distortion, so that the artist seems to have no attitude towards the phenomenon and the spectator is not distracted by speculation as to what is meant, is left free to concentrate on what is there."[3]

L. R.

1. William S. Rubin, *Dada, Surrealism, and Their Heritage.* New York: The Museum of Modern Art, 1968, p. 91
2. "Magritte par lui-meme," *L'Art Belge,* Magritte issue, January 1968.
3. David Sylvester, *Magritte.* New York: Frederick A. Praeger, Inc., 1969, p. 1

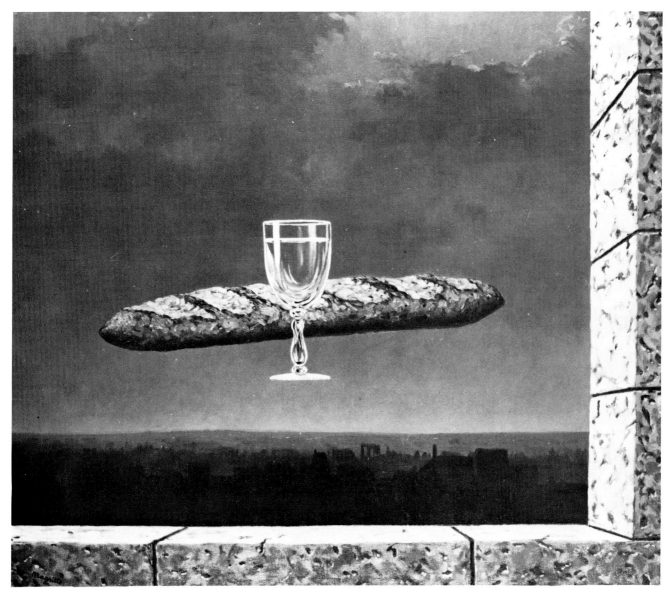

Plate 33

La Folie des Grandeurs (Delusions of Grandeur). 1962. Oil on canvas, 100.6 x 81.6 cm.
Menil Foundation Collection, Houston

Magritte has said of the partitioned nude woman of *Delusions of Grandeur*, "that was just a dream about the present: each torso section represents a past generation."[1] Magritte frequently depicted the truncated female torso as part of a polyptych, or as a separate, framed image in a room, often in conjunction with scenes of cloud-filled skies. However, in *Delusions of Grandeur* these elements are shown, not in self-contained compartments, but as inhabiting one consistent, illusionistic space.

Normally both sky and nude would communicate a sense of beauty, the sky being serene and blue, the nude a version of a classical torso. Yet the harmonious proportions of the torso and calmness of the sky are qualified by the variant scale of the nude's three parts and by the building blocks that interrupt the sky. With its stress on a world being pieced together, the final image is disquieting. Referring to *The Progress of Summer*, a similar painting, David Sylvester wrote, "It shows the building of sky, the building of earth, the fitting-together of fragments of a torso which are not parts of the same torso, for the abdomen is solid, as if done in clay, while the thorax is like a *papier-mâché* mask."[2] This representation emphasizes Magritte's deep-rooted differentiation between a real object, a mental image of the object that transcends proportions, and an illusion of reality as it is made visible in a two-dimensional picture.

In *Delusions of Grandeur* Magritte achieves additional impact with his appealing use of antithetic forms. The hollow construction of the rounded female body, open at its top and bottom planes, is set against the solid, impenetrable, flat-edged cubic blocks that are themselves enveloped by soft amorphous clouds.

L. R.

1. *Time*, June 21, 1948
2. David Sylvester; *Magritte.* New York: Frederick A. Praeger, Inc., 1969, p. 7

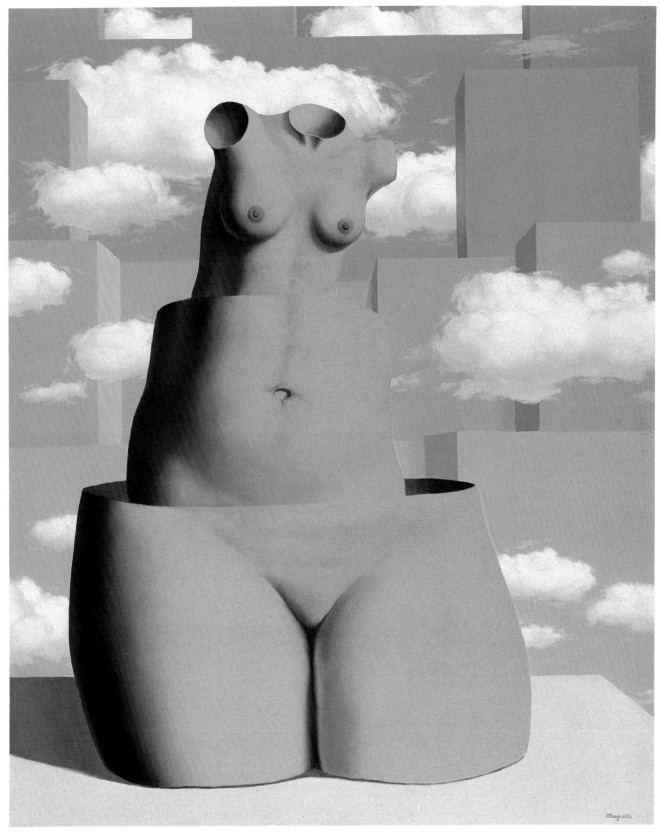

Plate 34

87

Perspective. (1963). Crayon, 35.9 x 26.9 cm. The Museum of Modern Art, New York. Gift of Harry Torczyner

In the 1963 drawing *Perspective* Magritte transforms a human figure into a coffin seated on a ledge. The image of the anthropomorphic coffin was not new to his art. In a 1949 paraphrase of Eduard Manet's *The Balcony*, Magritte converted the figures themselves into coffins. Magritte similarly parodied Jacques-Louis David's portrait of Madame Récamier by replacing or concealing her reclining figure with a casket.

A number of factors may have prompted Magritte to paint these wryly mordant works which, in one sense, impart a "perspective" on mortality. When he was fourteen his mother drowned herself. The art historian and critic John Canaday suggests that Magritte had known Antoine Wiertz's picture *Precipitate Burial,* in which coffins are upended in a fantastic manner.[1] A. M. Hammacher, in his monograph on Magritte, describes the artist's fascination with death and how, on visiting a friend who was a coffin-maker, Magritte spent an afternoon inside a coffin. Magritte's great interest in the writer Edgar Allan Poe's themes of death and afterlife may also have played a role in the appeal of these perverse scenes. However, they most likely stem from Magritte's attraction to playing in the graveyard at Soignies as a boy.

The period in the 1950s when Magritte portrayed figures encased in coffins coincided with his fully developed "Stone Age" images of petrified figures. The figures in the calcified works are transfixed; those suggested by the coffins are removed from sight. This last concept, which involves the idea of something being hidden, was an important theme in the artist's work. Magritte was insistent that the invisible was just the visible hidden by the visible. "The tree," he commented, "having become a coffin, disappears into the earth."

The texture of simulated wood, evidenced here by the coffin, features prominently in Magritte's work from the 1920s onward. It appeared in the floorboards of *Eternity* (Plate 28) and in the background of *The Thought Which Sees* (Plate 36).

L. R.

1. John Canaday, "Floating Rocks and Flaming Tubas," *Horizon*, Jan. 1962, v. 4, no. 3:76-82
2. Louis Scutenaire, *Rene Magritte.* Brussels: Editions Librairie Selection, 1947, p. 69

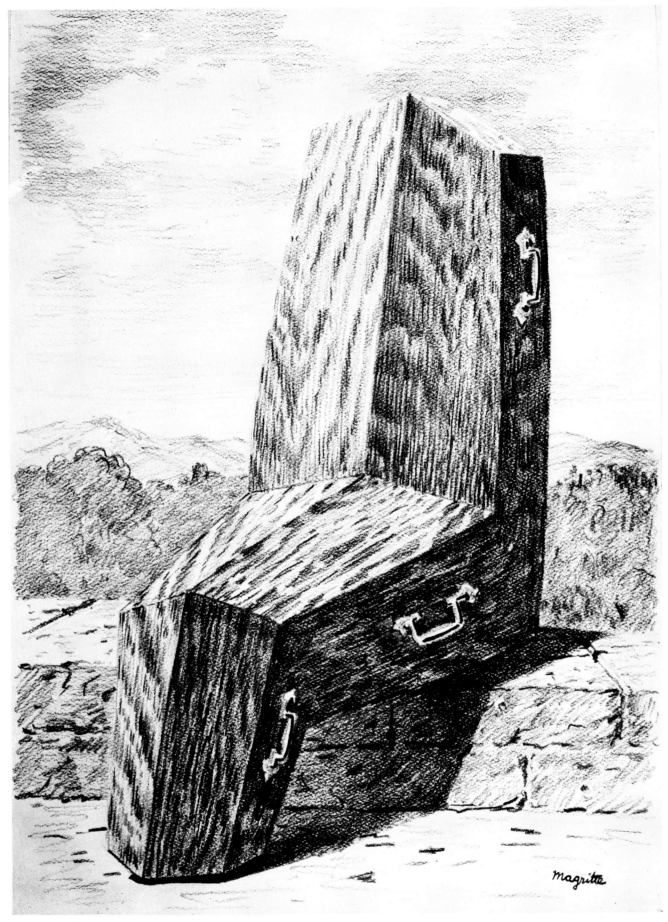

Plate 35

The Thought Which Sees. 1965. Graphite. 40.0 x 29.7 cm. The Museum of Modern Art, New York. Gift of Charles B. Benenson

Throughout his career, Magritte defined his interpretation of the concepts of painting, the visible world, and thought. "For me, thought is composed of visible things only, painting can render it visible." Or, "The art of painting is an art of thinking, and its existence emphasizes the importance to life of the human body's eyes: the sense of sight is actually the only one concerned in painting."[1] Also, "The art of painting—which actually should be called the art of resemblance—enables us to describe in painting, a thought that has the potential of becoming visible. This thought includes only those images the world offers: people, curtains, weapons, stars, solids, inscriptions, etc. Resemblance spontaneously unites these figures in an order that immediately evokes mystery."[2]

Magritte felt strongly that "painting must serve something other than painting." It must depict thought. Painting describes thought or makes it apparent, and thought evokes the mystery of visible experience. Thought then, comprised as it is of shapes found in the visible world, is in opposition to ideas: "An idea is not to be seen by the eyes. Ideas have no visual appearance, so it is that no image can represent an idea." Ideas therefore are more akin to symbols, in which Magritte insistently and frequently disavowed any interest. He felt the visible world was a more than adequate source of images. When asked if the drawing *The Thought Which Sees* had any symbolic significance, the artist answered: "It is not symbolic because I avoid imagining the imaginary, especially symbols." In response to another inquiry, he wrote: "Art, as I conceive of it, is not a subject of study but of attention to *the thought which sees*, without trying to know that which it does not see."[3]

The image of the man with the derby or bowler hat and ready-made dark coat appeared as early as 1926 in *The Menaced Assassin* (Plate 25). It appears frequently in the 1950s and 1960s. This image, which came to be associated with the artist himself, was used to challenge conformity. Depicted as part of the crowd—an ordinary man of the street, one of the respectable, bourgeois "tribe of clerks"—the image nevertheless is also removed from the crowd.

When he painted this man head-on and as a single figure, Magritte almost always concealed the figure's face from the onlooker, either by showing the man from the back or by affixing an object in space immediately in front of his face. Just as Magritte explored the relation between representation (the picture) and that which is represented (the object), he sought to separate the human figure as represented in his painting from man himself. This hidden, unseeing figure with the invisible face is an appropriate image for a drawing such as *The Thought Which Sees*, which describes the visible appearance of thought.

The Thought Which Sees deals with other motifs characteristic of Magritte's work, such as the idea of bringing the outside inside. Magritte frequently accomplished this by placing indoors a painting of a landscape seen through a window. Magritte describes this format: "In front of a window, as seen from the interior of a room, I placed a picture that represented precisely the portion of landscape blotted out by the picture. For instance, the tree represented in the picture displaced the tree situated behind it, outside the room. For the spectator it was simultaneously inside the room; in the picture, and outside, in the real landscape, in thought. Which is how we see the world, namely outside of us, though having only one representation of it within us."[4] Not only does this image simultaneously present us with two different spaces, but it also conveys an impression of transparency, another important theme of Magritte's. In *The Thought Which Sees* two outdoor scenes are confined within the outlines of two phantom-like "transparent" men. Where we would expect to see an open sky we are confronted with a wood-grained interior background. This disquieting, ambiguous space, which confuses the vaporous with the solid, the exterior with

90

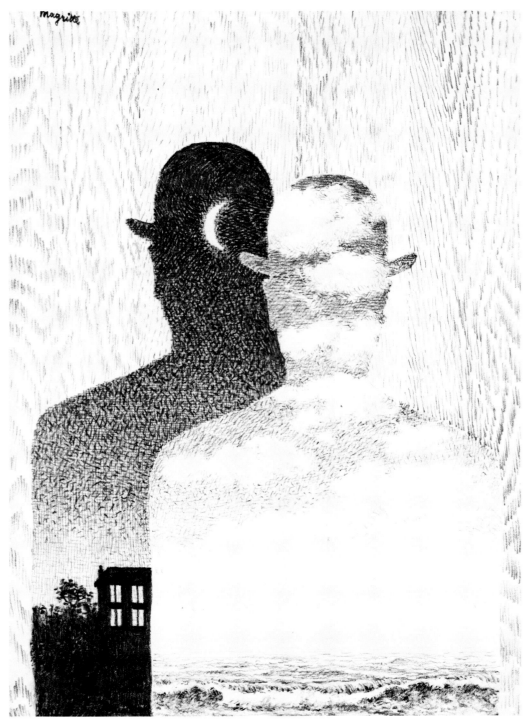

Plate 36

the interior, is typical of Magritte. So too is the contradiction of simultaneously coinciding two different times that is realized in the drawing by the juxtaposition of a daylight and night-time scene.

L. R.

1. René Magritte, "Le Véritable Art de Peindre," 1949 in Harry Torczyner, *Magritte: Ideas and Images,* New York: Harry N. Abrams, Inc., 1977, p. 217
2. René Magritte: statement in exhibition catalogue *René Magritte in America,* The Dallas Museum for Contemporary Arts and the Museum of Fine Arts of Houston, 1960 in Torczyner, p. 222
3. The Museum of Modern Art Questionnaire, July, 1966
4. René Magritte, "Lifeline," *View,* v. 7, no. 2, Dec. 1946, p. 22

Joan Miró

1893
Born April 20 in Barcelona to Michel Miró Adzerias, a goldsmith, and Delores Ferra.

1900
Attends school in Barcelona; takes evening drawing lessons.

1905
Fills sketchbooks, chiefly with drawings from nature made during visits to Tarragona and Palma, Majorca.

1907
Attends business school in Barcelona. Attends School of Fine Arts, La Lonja, and is influenced by two teachers, Modesto Urgell and José Pascó.

1910
Takes job as clerk with a Barcelona business.

1911
Contracts typhoid fever. Convalesces at his parents' home in Montroig.

1912
Enrolls in Francisco Galí's School of Fine Arts in Barcelona. Forms friendship with painter E. C. Ricart and ceramist Josep Llorens Artigas. Sees first Impressionist, Fauve, and Cubist works. Makes first paintings.

1915
Graduates from Galí's school. Shares studio with Ricart. Participates in drawing sessions at the Sant Lluch circle, where he works until 1918. Paints in a Fauve style.

1916
Attends the art dealer Ambrose Vollard's exhibition of French art in Barcelona. Reads avant-garde magazines and poetry by Stéphane Mallarmé, Guillaume Apollinaire, and Pierre Reverdy.

1917
Meets Francis Picabia.

1918
First one-man show at Galerie Dalmau, Barcelona. Joins *Agrupació Courbet*, a group of young painters associated with Artigas.

1919
Exhibits at the Barcelona Municipal. First trip to Paris (March-June) during which he meets Picasso and Maurice Raynal. Makes poster for magazine *L'Instant*. Thereafter spends winters in Paris and summers in Montroig (until 1933).

1920
In Paris meets Reverdy, Tristan Tzara, and Max Jacob. Participates in Dada activities. At the end of the year takes a studio that adjoins André Masson's.

1921
Begins *The Farm* (completed 1922). First one-man show in Paris at the Galerie La Licorne with catalogue preface by Raynal. Exhibition is a complete failure.

1922
Through Masson meets Michel Leiris, Georges Limbour, and Antonin Artaud.

1923
Exhibits at the Salon d'Automne with other Catalan painters. Friendships with Jacques Prevert, Ernest Hemingway, and Henry Miller.

1924
Joins André Breton, Louis Aragon, and Paul Eluard in Surrealist group.

92

1925
Exhibition at Galerie Pierre, Paris. Participates in first Surrealist group exhibition at same gallery.

1926
Collaborates with Max Ernst on the design of sets for Diaghilev's ballet *Romeo and Juliet*. Both artists criticized by other Surrealists. Work is shown for the first time in the United States.

1927
Moves studio to the Rue Tourlaque in Montmartre where his neighbours are Ernst, Eluard, Jean Arp, and René Magritte.

1928
Visits Holland. Paints Dutch Interiors from postcards of old Dutch masters. Large exhibition at the Galerie Georges Bernheim. Makes first *papiers collés*.

1929
Marries his cousin, Pilar Juncosa, in Palma.

1930
Exhibition at the Galerie Pierre. Makes first lithographs and constructions. First one-man show in the United States at the Valentine Gallery, New York.

1931
Daughter, Dolores, born in Barcelona.

1932
Creates sets, costumes, curtains, and "toys" for the Ballets Russes de Monte Carlo production of *Jeux d'enfants*. First one-man show at the Pierre Matisse Gallery, New York. Matisse becomes his American dealer.

1933
Makes first etchings. Executes eighteen large canvases from collages. First one-man show in London at the Mayor Gallery.

1934
Begins "savage" period with large pastels. Makes paintings on sandpaper and executes cartoons for tapestry.

1935
Participates in Surrealist exhibition at Tenerife, Canary Islands.

1936
Exhibits with contemporary Spanish painters at the Jeu de Paume, Paris. Leaves Spain and does not return until 1940. Included in The Museum of Modern Art's "Cubism and Abstract Art" and "Fantastic Art, Dada, Surrealism" exhibitions.

1937
Lives in Paris. Creates poster for the Spanish Loyalists and paints *The Reaper* for the Spanish Pavilion at the Paris World's Fair.

1940
Begins series of twenty-three *Constellations* at Varengeville-sur-Mer in Normandy. Returns to Spain, settling in Palma.

1941
Major retrospective at The Museum of Modern Art, New York.

1942
Returns to Barcelona.

1944
Makes first ceramics with the assistance of Artigas. His mother dies.

1945
Exhibition of *Constellations* and ceramics at the Pierre Matisse Gallery.

1947
Visits the United States for the first time to paint a mural for the Terrance Hilton Hotel in Cincinnati. Lives and works in New York. Meets Adolph Gottlieb.

1948
Returns to Paris after an eight-year absence. One-man show at the Galerie Maeght, Paris.

1949
Retrospectives at the Kunsthalle, Bern, and the Kunsthalle, Basel.

1950
Paints mural for Harvard University.

1953
Exhibitions celebrating his sixtieth birthday at Galerie Maeght, Pierre Matisse Gallery, and Kunsthalle, Bern.

1954
Wins Grand Prix International for graphic work at Venice Biennale. Stops painting until 1959.

1956
Moves studio and family from Barcelona to Palma. Major retrospective in Brussels, Amsterdam and Basel.

1957-58
Works on two ceramic murals for the UNESCO building in Paris which win Guggenheim International Award.

1959
Second trip to the United States, in connection with retrospective at The Museum of Modern Art, New York.

1961
Third visit to the United States.

1962
Large retrospective at the Musée Mational d'Art Moderne in Paris. Exhibition of engravings at the National Museum of Western Art, Tokyo.

1963
Major retrospective at the Tate Gallery, London.

1964
Fondation Maeght in Saint-Paul-de-Vence, France, opens featuring a labyrinth decorated with large sculptures and ceramics by Miro. Participates in "Documenta III" in Kassel, West Germany.

1965
Fourth visit to the United States.

1966
Visits Japan. Retrospective of graphic work at the Philadelphia Museum of Art.

1967
Wins Carnegie Institute prize for painting.

1968
Fifth visit to the United States. Retrospective at the Fondation Maeght in honour of his seventy-fifth birthday (travels to Barcelona). "Miro Year" celebrated in Barcelona, including the first Miro exhibition held in Barcelona in fifty years.

1969
Retrospective at the Haus der Kunst, Munich.

1970
With Artigas creates large ceramic mural for Barcelona's airport. Exhibits at Expo '70 in Osaka.

1971
Exhibition of sculpture at the Walker Art Center, Minneapolis (travels to Cleveland and Chicago).

1972
Establishment of the Fundació Joan Miró, Centre d'Estudis d'Art Contemporani, Barcelona. Exhibition at the Solomon R. Guggenheim Museum, New York.

1973
Large exhibition at the Fondation Maeght in honour of his eightieth birthday. Major exhibition at The Museum of Modern Art, New York.

1974
Concurrent exhibitions in Paris of paintings, sculpture, and ceramics at the Grand Palais and graphic work at the Musée d'Art Moderne.

1975
Opening of the Fundació Joan Miró, Centre d'Estudis d'Art Contemporani, Parc de Montjuic, Barcelona.

1976
Formal inauguration of the Fundació Joan Miró with exhibition of drawings.

1978
Retrospective held at the Museo Español de Arte Contemporanea, Madrid.

1979
Major retrospective in honour of his eighty-sixth birthday at the Fondation Maeght.

1980
Exhibitions in Mexico City and Caracas. Lives and works in Palma.

Prades, the Village. (1917). Oil on canvas, 65.7 x 73.3 cm. The Solomon R. Guggenheim Museum, New York

Although Miró did not fully realize his personal style until his Surrealist paintings of 1923-24, his accomplishments as a painter were evident in his works of the preceding years. Among these were a number of landscape paintings, including *Prades, the Village*, that he made during trips to the Spanish countryside.

Painted in a style similar to that of the French Fauves, these paintings are characterized by the use of pure unmodelled tones placed next to each other to achieve expressive qualities. Miró's use of colours is indebted to Matisse. "Matisse," he wrote, "taught us all that autonomous color, with or without modeling, could carry structure through contrasts and subtle juxtapositions."[1] However, Miró created a style too personal to be classified as pure Fauve. He assimilated and integrated not only Fauvism and Matisse but numerous other influences as well: Cézanne, the decorative patterning and structure of Cubism, the "primitiveness" of Rousseau, Expressionist distortion, the writhing forms of van Gogh, and the juxtaposed bands of colour of Orphism. It is likely that Miró was familiar with the latter from an exhibition of Robert Delaunay's work that took place in Barcelona in 1916-17. As well, Miró's palette was composed of the saturated off-shades and prismatic rainbow hues characteristic of the Impressionists rather than of the brilliant, clear colours of the Fauves.

During this period Miró sought to combine his expressive, lyrical colour and decorative patterning with an objective depiction of the autonomous shapes of reality. In *Prades, the Village*, he retains the external appearance of the village and church while reducing the landscape foreground to geometric forms consisting of parallel wavy lines and superimposed chevrons. These herringbone patterns, while non-figurative, do however capture the rhythmic sense of climbing vines and plants and the furrows of ploughed fields. Such patterning points the way to the flattened, schematized forms so vital to Miró's later works.

L.R.

1. James Thrall Soby, *Joan Miró*. New York: The Museum of Modern Art, 1959, p. 28

Plate 37

The Carbide Lamp. Montroig, Paris, 1922-23. Oil on canvas, 38.1 x 45.7 cm. The Museum of Modern Art, New York

During 1921-22 Miró encapsulated virtually the whole of his vision of rural Catalonia in one painting, the celebrated *The Farm*. It is an image of the family at Montroig—a place so vital to him that he has returned there every summer, whether from Paris, Barcelona, or more recently, Palma. *The Farm* at once subsumed and extrapolated the motifs of Miró's landscapes of the five years preceding its execution. It also represented the epitome of his "detailistic" realism; the myriad, mostly small motifs that spot its surface are fastidiously executed, and the whole shimmers with an ornamentalism beyond that of his previous paintings.

The Farm required immense effort and concentration. Miró speaks of feeling entirely drained, indeed a bit lost, after its completion. A few months later, during the summer in Montroig, he began to dispel this sense of crisis by starting five pictures, all but one of them small-format still lifes, which were to be finished in Paris during the following autumn and winter. Of these, *The Carbide Lamp* and *Ear of Grain* may be thought of as a coda to *The Farm*, inasmuch as the still-life motifs look as though they might have been excerpted from the larger picture. At the same time, Miró's anti-anecdotal isolation of these objects in the fields of the new pictures and the rigorous, ascetic geometries of their compositions constitute an antithesis to the prolixity of *The Farm*.

This "focusing down" on a few humble objects was Miró's way of finding himself again. He was to do much the same thing early in 1937 when a temporary crisis led him to paint *Still Life with Old Shoe* (Plate 45). From Montroig he wrote his friend Roland Tual:

> The effort of my last picture *(The Farm)* does not permit me to undertake comparable subjects. I search the kitchen for humble objects, ordinary objects—an ear of grain, a grill—from which I make a picture. To communicate emotion through objects you must love them immensely because you may be sure that in the contrary case you will make a picture wholly without interest. I become more demanding of myself from day to day, an exigency which makes me rework a picture if one of its elements is a millimeter too much to the right or left. In the room which serves as my atelier I always have books that I read during the intervals in my work. All this requires a continual sense of spiritual vibration. When I paint, I caress what I am making, and the effort to endow it with a meaningful life tires me enormously. Sometimes, after a session of work, I fall into an armchair, exhausted, as after the act of lovemaking.

The crystalline surfaces of *The Carbide Lamp* and *Ear of Grain* do not at all betray the intense labour of Miró's continual reworking as he brought the compositions into adjustment (he has spoken of the "especially rigorous discipline" of that summer). Of the two, *Ear of Grain* is the more conventional in the spatial disposition of its forms, and it is the more easily interpreted. The shapes of the crockery jar, the strainer, and the ear of grain splay rightward from the left of the canvas, the downward diagonal of the grain counterbalanced by the upward movement of the contour of the gray tabletop. In variance with the tilting of the latter, the jar is seen from a position only slightly above profile, while the strainer is pictured entirely from above—a series of perspective disjunctions by then long sanctioned by the Cubists. Nevertheless, Miró inserted "ground lines" under the bowl and at the bottom edge of the strainer, as if he felt the need to clarify their disposition in space.

Plate 38

The motifs in *The Carbide Lamp* are more disjoined, more contradictory in position and scale that those of *Ear of Grain*. The lamp itself—there was no electricity then in Montroig—sits on a trapezoid of ochre which Miró introduced "to keep equilibrium," and which might be read as a stylized symbol of cast light. This ochre shape is itself set in a field of gray that we take to be the tabletop but which is now identical with the picture field itself and thus entirely vertical. The tomato in the lower left corner has been halved vertically to reiterate the line of the frame, already echoed by the left contour of the trapezoid; it has also been sectioned laterally to reveal its interior, whose ornamental stylization provides a foil for the austerity of the picture as a whole. On the right, tilted at a distorting angle, and immensely enlarged to provide dramatic diagonal accents, is a metal stand for a clothes iron.

The objects in *The Carbide Lamp* are conventional in themselves; they do not interact to release those mysterious poetic signals which, under the influence of Surrealism, Miró's iconography would later give off. Yet there *is* a sense of mystery in the structural disjunctions and juxtapositions of their forms, and it is perhaps this which Picasso—an early admirer of Miró's art—had in mind when he characterized the picture as "poetry".

(adapted from Rubin, *Miro,* pp. 18-20)

99

Painting. 1925. Oil on canvas, 114.0 x 145.1 cm. Mr. and Mrs. Morton G. Neumann, Chicago

Despite his considerable success as a decorative Cubist, Miró had found himself constrained and frustrated by that style's rigour and objectivity. Introduced into the Surrealist circle in 1924 by André Masson, with whom he had an adjoining studio, Miró felt suddenly liberated. He became obsessed with poetry—"I gorged myself on it all night long"—and was excited by the possibilities of automatism as a way of realizing poetry in visual form. He included in his paintings shapes such as ears or eyes which announced the biomorphology that by the end of 1925 would dominate his painting and serve as a vehicle for his fantasy.

Miró was now leaving the Cubists behind with a vengeance. "I shall break their guitar," he declared. Although Cubist space and certain Cubist compositional distributions continued to inhabit the infrastructure of his pictures, the overall appearance of these images was decidedly new. During the next few years, and to a lesser extent until the Second World War, most of Miró's work fell stylistically between carefully planned, tightly painted, flat patterning and loosely painted, "automatic" improvisations.

Painting exemplifies the boldness and spareness characteristic of the automatic manner. Letting his brush wander freely over the monochromatic reddish-brown wash ground, Miró found forms that began to suggest a human hand, a heart, and a shooting star. He frequently used the triangle and amorphous cloud-like forms to allude to women. Hence the hand reaching for the heart is an appropriate image for a painting which serves as a love poem to a woman.

"Rather than setting out to paint something," Miró said later of his method, "I begin painting and as I paint the picture begins to assert itself, or suggest itself under my brush. The form becomes a sign for a woman or a bird as I work... The first stage is free, unconscious." Miró's automatism was not pure, nor even as rapid or little edited as some of Masson's. It is noteworthy that Miró qualified the description of his procedures cited above by adding that "the second stage is carefully calculated." Pure automatism, like pure accident, is inimical to art.

Though Miró's genius as a colourist was not entirely realized until the 1930s, his earlier pictures already established him as the greatest colourist in the generation after Matisse. From the latter he learned to avoid the heavy impastos that are alien to the insubstantial, essentially optical nature of colour; Miró's paint is either brushed out so as to look transparent, as in *Painting*, or brushed over until a texture-less evenness is obtained.

(adapted from Rubin, *Dada, Surrealism, and Their Heritage,* pp. 66-68)

100

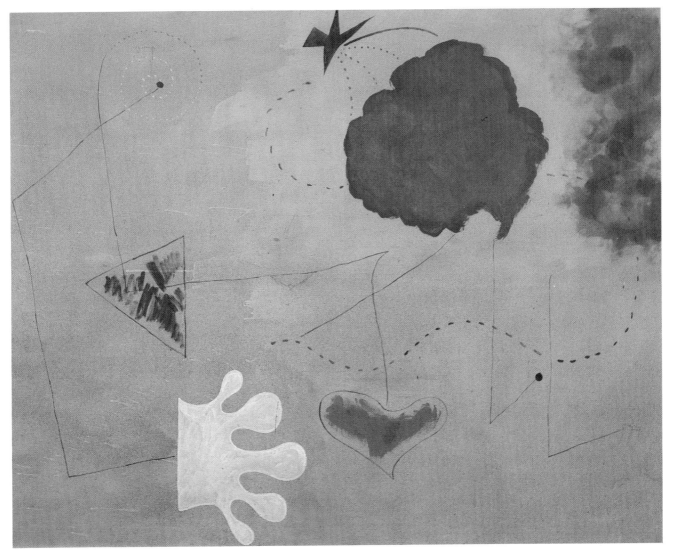

Plate 39

Person Throwing a Stone at a Bird. 1926. Oil on canvas, 73.7 x 92.1 cm. The Museum of Modern Art, New York

In 1926-27 Miró executed a number of landscape-type images that reflected a greater interest in anecdote than had been characteristic of the paintings of 1925. The motifs of *Person Throwing a Stone at a Bird*, particularly the bird itself, are relatively illustrative, and the horizon line immediately re-establishes a space more terrestrial than the apocalyptic reaches of many of the works of the previous year. The background of the painting is a beautiful triad composed of a yellow earth and a green sky separated by a black sea. The irregular shoreline, its pinnacles accented by grace notes of lavender and red, descants the almost straight horizon line, which is, however, slightly tilted.

The figure throwing the stone is an amoeboid biomorph with a Cyclopean eye and giant foot, seemingly derived from an earlier picture titled *The Statue.* Its two arms are represented by a single line, next to which a lone dot was placed, Miró says, to indicate its centre; this line is set crossbow-like against the curved, dotted line that indicates the trajectory of the stone. A not unsimilar apposition is repeated in the straight body and curved wing of the bird, whose tail inverts the colours of earth and sky while its blue head and red crest provide the piquant colour accents which resonate the large colour fields of the composition.

As in the thirteen other landscapes of this series from the summers of 1926 and 1927, the execution is closely controlled and the surfaces are evenly applied as if the relatively anecdotal character of the scene evoked a tighter facture. But while Miró's manner during these years oscillated between these modes, there was nothing programmatic about his method of applying the paint, and a variety of "handwritings" are often found in the same picture. Certain motifs were carefully drawn and evenly executed despite the prevailing painterliness of its handling. In *Person Throwing a Stone at a Bird* Miró elected to make the sky brushy—and hence atmospheric—despite the picture's predominantly fastidious facture.

The biomorphic representation of the "personage" here shows Miró exploiting more emphatically than earlier what was by then the characteristic Surrealist form of language, one which by its very ambiguity enhances the possibilities of humour. Established by Jean Arp, subsequently elaborated in personal ways by Miró and Masson, and later by Yves Tanguy, Picasso, Salvador Dali, Matta, and others, this vocabulary of biomorphic shapes had arisen as an alternative to the prevailingly rectilinear structures of Cubism.

(adapted from Rubin, *Miro*, p. 37)

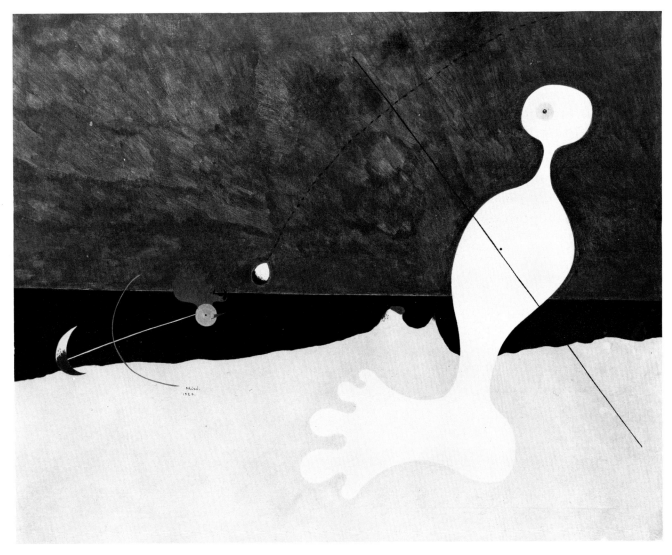

Plate 40

103

Portrait of Mistress Mills in 1750. Paris (early) 1929. Oil on canvas, 116.7 x 89.6 cm. The Museum of Modern Art, New York. The James Thrall Soby Bequest

Portrait of Mistress Mills in 1750, after an engraving of a portrait of that lady by George Engleheart (1752-1829), is the masterpiece of Miró's four "Imaginary Portraits," his most important series of 1929. Insofar as they were based on images of older paintings, the portraits reflect a continuation of practices established in the "Dutch Interior" series of 1928. As a group, however, they are simpler, less anecdotal, and wander somewhat farther from the works that inspired them.

Reproductions of the Old Masters substituted for the Surrealist practice of "automatic" doodling in getting the Portraits started. Each portrait was developed through a series of metamorphic drawings, its expressive ambience becoming increasingly that of *miromonde*. Unlike Picasso in his extrapolations of the Old Masters begun a few years later, Miró does not explore the psychology of the figures in his borrowed motifs or enter into their narrative situations. Rather he converts everything into his own terms, seizing more on the marginal aspects of the earlier pictures than on their total concepts. Thus Mistress Mills' face becomes smaller than her bright red ear—and less visually engaging. And her ribbon, the broad ochre band that projects from her hat and terminates in a bow, becomes one of the most arresting and elusive shapes in the composition. Miró's eye was caught by the ornamental aspects of the Engleheart work; he cared so little for the original that he forgot the identity of its author. Just as ornament is what attracted Miró in the Engleheart, so it is ornament that he adds to the conception, both on the illustrative and formal levels; he has, for example, put a spangled clasp in Mistress Mills' hair, and gifted her with a double necklace.

In *Portrait of Mistress Mills in 1750* Miró achieved a compactness of design rarely matched in his later work, a compactness that results from equalizing the impact of figure and ground. In *Dutch Interior* of the previous year, Miró had squeezed both figure and ground into the picture plane, but only the figural elements were endowed with any significant definition as shapes; a dog, cat, frog, knife, and other details seen against the brown floor are fascinatingly contoured, but the brown area itself is just a foil, an unshaped *repoussoir*. In *Mistress Mills*, the reserve areas of vermilion on the left and red-brown on the right, against which the subject is set, have an autonomous quality, a definition of shape comparable in interest to that of the contiguous green upper torso and brown skirt. As if to symbolize this equation of figure and ground, Miró included in the lower right corner of the canvas a kind of visual charade consisting of interpenetrating black and yellow abstract shapes—a stylization of the light and shadow areas in the same location in the Engleheart—either one of which may be read as figure or ground. This contouring of the surface in terms of more reciprocal figure/ground relationships was to prove very rare in Miró's works, which are generally composed of figures profiled against a less clearly defined atmospheric ground.

In *Dutch Interior* Miró had already established himself as a master colourist. In earlier pictures his prismatic colours were often muted, and when not, they were used primarily as isolated accents, while the blacks tended to work as local modelling more than as autonomous colour. In *Mistress Mills*, Miró advanced to an even stronger reliance on pure colour than in *Dutch Interior*, giving it a breadth and transparency worthy of Matisse. Indeed, it was Matisse, Miró asserted, "who taught us that color alone...could carry (a picture's) structure through contrasts and subtle juxtapositions." The large areas of prismatic hues dominate the ornamental drawing, and the blacks—now functioning as colour areas rather than as shading or as contours—provide a foil for their brilliance.

(adapted from Rubin, *Miro*, pp. 49-50)

104

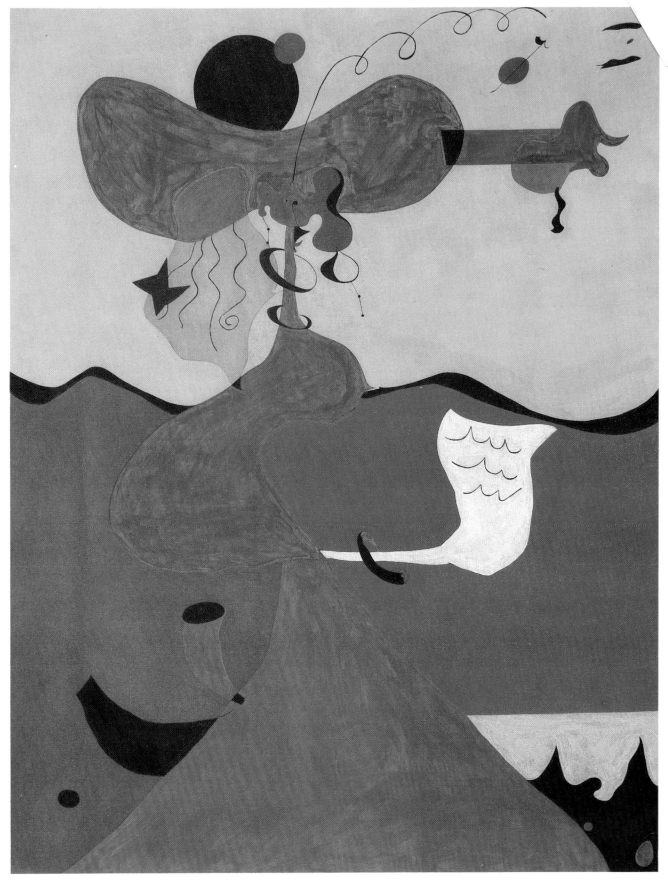

Plate 41

Collage. Montroig, summer 1929. Pastel, ink, watercolour, crayon and paper collage, 72.7 x 108.4 cm. The Museum of Modern Art, New York. James Thrall Soby Fund

In the summer of 1929, not long after he had painted *Portrait of Mistress Mills in 1750* (Plate 41), Miró executed this collage at his family home in Montroig. It shows an even more marked tendency toward simplification and generalization of the forms than the painting. We are here once again transported into a kind of microcosmic primal universe, an ambience that is a metaphor for the recesses of the artist's consciousness. On the left, against a green ground, Miró has traced the contours of two amoeboid creatures; the larger one rises from the lower left to greet its mate, whose single distinguishing feature is its circular black eye. The simplicity of these biomorphic shapes is simultaneously echoed and descanted in the rough circular or rectangular contours of all the superimposed collage elements, with the exception of the bluish vertical that descends to the right of the central axis. Only in the upper right, where the drawing is more intricate, do we find traces of the typical Miró of the mid-1920s. The awkward, irregular edges of several elements in *Collage* bespeak an improvisational abandon comparable to that of Miró's freest paintings of 1925-26. The purposely casual manner of the gluing was intended to leave a relief of crinkles and folds and to allow the edges of many of the forms to pull away from the ground.

(adapted from Rubin, *Miro*, p. 50)

106

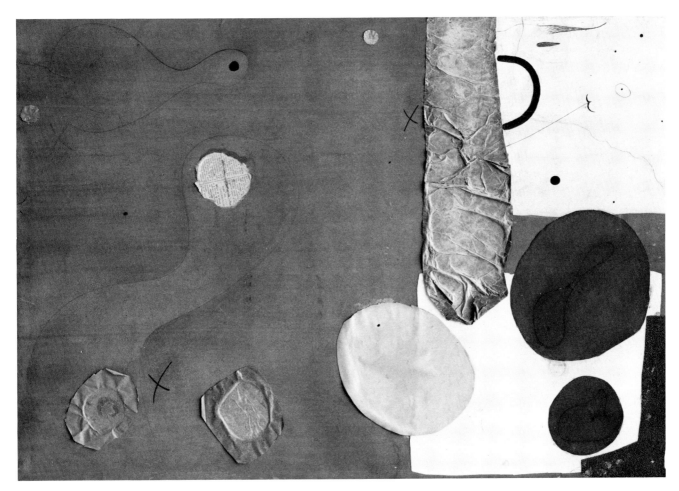

Plate 42

107

Object. 1931. Assemblage: painted wood, steel, string, bone, and a bead, 40.0 cm high, at base 21.0 x 12.0 cm. The Museum of Modern Art, New York. Gift of Mr. and Mrs. Harold X. Weinstein

While many of Miró's 1928-29 collages contained elements in slight relief, it was not until mid-1930 that he began making what may properly be called relief sculpture. *Object*, executed in the following year, is still entirely within this mode but the relief is higher than in previous work and the red element at the top extends behind the ground plane. Although Miró did not make sculpture in the round until the mid-1940s, he experimented throughout the 1930s with constructed objects intended to be seen from all angles. *Object* anticipates this direction.

Object makes some obvious and other less obvious anthropomorphic allusions. We know on the authority of Miró himself that there are no non-figurative elements in his work; however elliptical, however distant the allusion, every form Miró employs—whether in his paintings, his constructions, or his later sculptures—is associated metaphorically with something outside his work. Small as it is, *Object* has a disquieting, intriguing presence that owes much to its deliberately ambiguous allusiveness. The viewer will probably immediately read the top-most blue form and the projecting nail grasped by an unusual, predatory bone as phallic, as they are unequivocally intended to be. But poetry is best served when not completely explicit. The viewer is hence licensed to extrapolate from immediate specific clues a more comprehensive reading.

It is in the nature of Miró's chameleon art that no single interpretation can ever be considered "correct". However, recognizing this and given the sexually charged nature of the iconography we find in almost all of Miró's work, a plausible reading of *Object* might cast its puzzling forms as a couple—the male represented by the larger unit at the left surmounted by an aggressively phallic head (a common double identity in the art of both Miró and Picasso) and the female by the smaller box-like unit at the right, enclosing within the compressed and secretive space of its contours a small, suspended, blue head. However Miró's fantasy may lead the viewer's, *Object* embodies both a sense of gravity and gaiety, that special atmosphere of *miromonde.*

C.L.

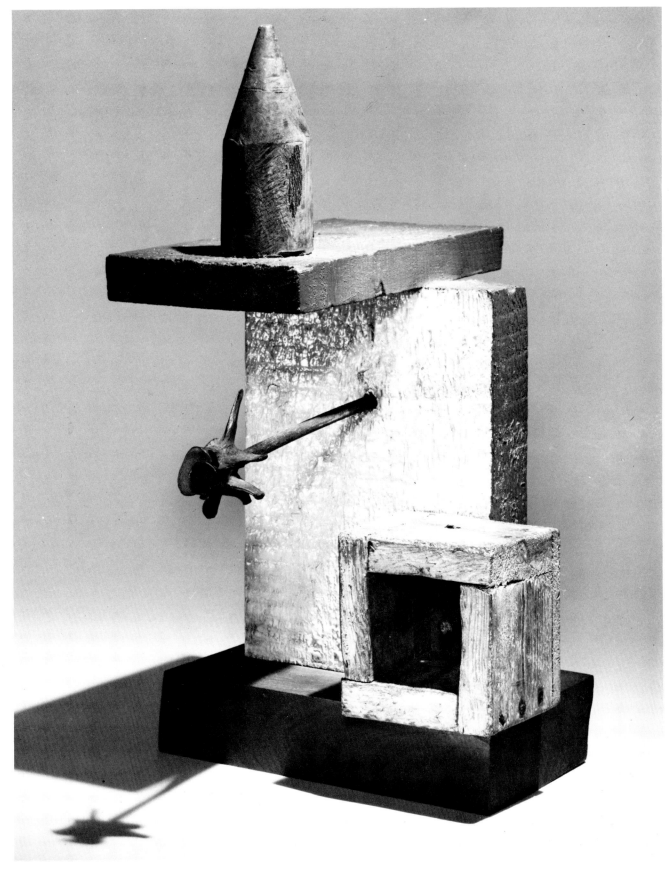

Plate 43

Painting. 1933. Oil on canvas, 174.0 x 196.2 cm. The Museum of Modern Art, New York. Gift of the Advisory Committee

Because of financial difficulties, Miró and his wife spent the spring months of 1933 with his parents in Barcelona. There, in the apartment in which he had been born, working in an attic room arranged as a studio, he executed a group of eighteen large paintings that in the consistency of their realization marked a new level of achievement for him.

These pictures also serve as a general index to a change in his art in the 1930s. The period 1924-29 had been characterized by an astonishing morphological variety and a constant invention of new compositional ideas. The 1930s were more exploitative than explorative; there were, in comparison, fewer new ideas. But many possibilities first envisaged in the 1920s were consummated only in the 1930s. Intricate iconographic programs gave way to less anecdotal conceptions realized in a more restricted vocabulary of signs; compositions became broader, simpler, and more monumental, their formats larger; as compared to the immensely variegated, minutely dosed palette of the later 1920s, colour became more luminous and was increasingly embodied in large areas of primary hues.

Like the other seventeen oils in this series, *Painting* was based on a collage of images of machines and other utilitarian objects cut from catalogues and newspapers. All eighteen collages were made before any of the paintings were undertaken, and were strung across the walls of Miró's little studio so that he could study them. The paintings were executed between March and June of 1933, often at intervals of just a few days. Each completed canvas had to be unstretched and rolled up to give the artist room to work on the next one.

The preparatory collage for *Painting* shows cut-outs of machine tools of differing size and complexity glued to a plain white ground. These forms played little or no role in the first phase of the painting, however, which involved the division of the canvas ground into soft-edged modulated rectangles of bottle green, smoky blue, dark rust, and brown. Such passages, which are luminous and atmospheric, functioned as foils for the biomorphic motifs inspired by the collage elements. The latter were painted over the rectangular grounds either as panels of flat opaque colour (mostly black) silhouetted against the luminous atmosphere or as "transparent" figures, through whose firm outlines the ground is visible. While certain divisions of the background—the green rectangle at the top, for example—seem to have been suggested by the particular distribution of elements in the collage, the relation of the background panels and foreground motifs appears somewhat arbitrary.

As Miró translated his ideas from the collage onto the large canvas—working from the former, he recalls, as if *d'apres nature*—the machine forms shed their details and their rigid contours to become simple biomorphs, wholly devoid of the meandering Art Nouveau contours and unravelling ornament of Miró's earlier drawing. Taken together, these shapes seem to suggest nothing so much as a serene pastorale of grazing and playing animals. Commentators have been universal in seeing horned quadrupeds and—at the upper left—a seated dog. The forms in the lower centre suggest an animal on its back playing with another—a motif also found in Paul Klee, whose images of fantastical animals are often similarly suspended against vague atmospheric grounds.

It is, of course, futile (and undesirable) to assign specific meanings to the forms in *Painting*. The configurations here have shed the appearances of machines but have not yet acquired those of animals. Neither, however, are they "pure" formal entities. More than in his works of the 1920s, Miró is here using biomorphism in the ambiguous spirit in which Jean Arp had first used it almost two decades earlier, choosing the form which connotes much but denotes nothing.

110

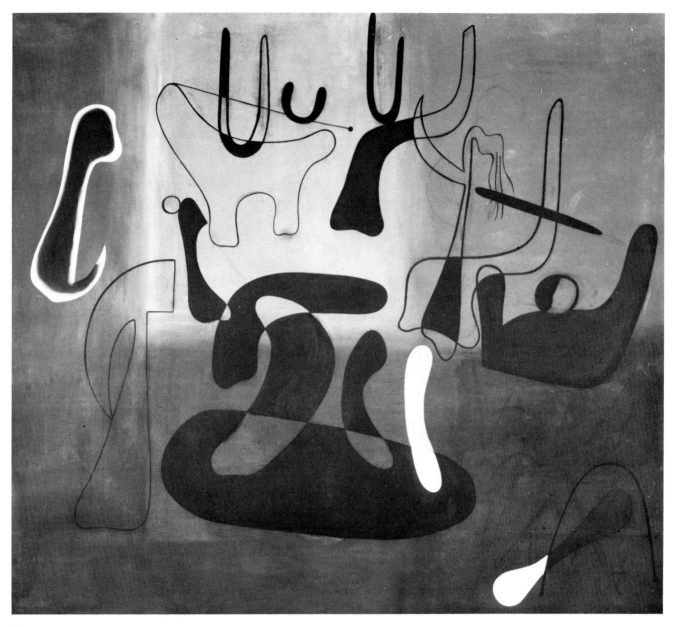

Plate 44

In *Painting* Miró was less dependent than heretofore on the improvisational aspects of "automatic" procedures. Something of the serenity, the relative detachment of *Painting* seems to depend upon this use of the collage as a model. Indeed, Miró appears to have purposely chosen machine forms for the preparatory collages—forms so alien in shape and spirit to his own organic world—in order to "set up a barrier...between his creative enthusiasm and the actual execution..." The choice, however, also measures the distance Miró had traversed—in the sense that the machine forms were a conscious reference to the past, to the Dada paintings and catalogue-like illustrations of machines by Francis Picabia, whom Miró first met in Barcelona in 1917. But the mystery of the machine as such, and the idea of the machine as analogue of human functions, had no interest for Miró. We see none of the irony of Marcel Duchamp's machines, nor Picabia's wit in Miró's picture. Nevertheless, *Painting* is imbued with a gentle and indulgent humour, expressed in part through the subsumption of the machine forms into what appears a more timeless, archetypal, pastoral symbolism that reaches back as far as Miró's beloved Altimira caves.

(adapted from Rubin, *Miro*, pp. 58, 60)

Still Life with Old Shoe. Paris, 1937, January 24-May 29. Oil on canvas, 81.3 x 116.8 cm. The Museum of Modern Art, New York. Gift of James Thrall Soby

The tragic realism of this picture has little in common, affectively or stylistically, with the realism of Miró's work prior to 1924. It emerged suddenly in 1937 and appeared only once again, in the hallucinated *Self-Portrait* of 1938. The painting marks a momentary crisis in Miró's conception of himself, his art, and the latter's relation to the public.

Miró had never displayed an interest in politics, but the fratricidal Spanish Civil War forced him to take sides. The artist was "almost sick with anxiety," and, as was the case with Picasso, the tragedy not only profoundly touched his consciousness, but momentarily redirected his art. *The Reaper*, the large mural he painted for the Spanish pavilion of the Paris World's Fair in 1937, is generally considered Miró's counterpart to Picasso's *Guernica*, likewise commissioned for that pavilion. Like *Guernica*, *The Reaper* dealt with current events through symbolic allusion. More manifestly *engagé* was Miró's poster *Aidez l'Espagne*, which shows a figure wearing what appears to be a Catalan *barreta* giving the clenched-fist Loyalist salute. Miró's inscription on the poster, however, clearly indicates the elevated, almost suprapolitical tone of his commitment: "In the present struggle I see, on the Fascist side, spent forces; on the opposite side, the people, whose boundless creative will gives Spain an impetus which will astonish the world."

The most profound counterpart to *Guernica* in Miró's art is the modest *Still Life with Old Shoe*, in which Miró spells out his sense of "the people" by transfiguring a group of their humble possessions. These are juxtaposed not on a table as in a conventional still life, but in a bleak landscape oppressed by a sky in which an ominous shadow floats in on the left, while the black clouds which converge on the right mingle with "the sinister colours of a great conflagration." The darkness, tragic in connotation, is mitigated by clusters of pure colour which seem to emanate from within the inanimate objects—as if Miró's brush had suddenly revealed their potential spiritual content.

The almost disconcerting intrusion of realism into Miró's style at this point in his career was a result of many concerns. Like other great modern painters, Miró had created a personal visual language that could be easily read only by those familiar with advanced twentieth-century painting. It seems certain that during the war that racked Spain Miró questioned whether his art, so beyond the comprehension of all but a few of his countrymen, was sufficiently in the service of their humanity. It was not an interest in particular causes or in serving the ends of political propaganda, but the desire to communicate more readily that must have led Miró, like some other artists of his generation, to Social Realism.

Indeed, Miró's painting had never been—nor would it ever be—wholly abstract; however summary or elliptical his symbols, they always referred to something concrete. During the early 1930s, however, his private sign language had become even more remote from nature than it had earlier been—hence more difficult to read. And it is therefore not surprising that the crisis which led to Miró's return to realism in *Still Life with Old Shoe* should have been anticipated by a return to sketching from the model. This Miró had already begun in the summer of 1936, side by side with the students at the Académie de La Grand Chaumière. The realism of *Still Life with Old Shoe* thus culminated plastically as well as thematically the rediscovery of his roots, and constituted a not unexpected reflex in a period when the artist could hardly bring himself to paint, and when, it has even been argued, his imagination was "running dry".

The execution of *Still Life with Old Shoe* may be thought of as a ritualistic recapitulation of Miró's mastery of the primary materials of his art. It is clear that its successful realization profoundly reassured the painter. Miró actually set

112

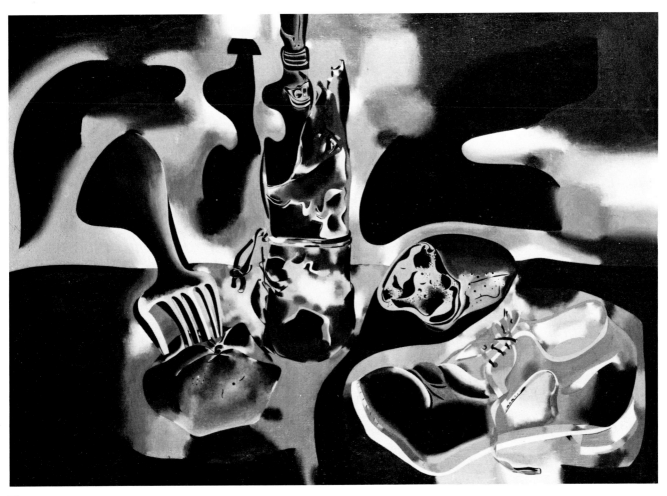

Plate 45

up the objects—an apple with a fork plunged into it, a partially wrapped gin
bottle (the letters GI... are visible just below its neck), a broken loaf of bread,
and an old shoe—on a table of the mezzanine of the Pierre Loeb gallery. He came
in almost every day for a month to paint, then moved his assembly of objects to
a studio he had just taken on the Rue Blanqui—where he continued to work on
the canvas for another four months.

It has often been observed that the inclusion of the old shoe is reminiscent of
van Gogh. The Dutch painter was one of Miró's favourites in his early years, and
Miró certainly wished to express here a van Gogh-like solidarity with those who
live close to the earth. But, in this instance, the analogy with van Gogh goes
beyond the inclusion of a shoe as such and touches on the whole psychology of
picture-making. When van Gogh felt most psychologically unsure, when his grip
on the world about him was loosened, he often found that by isolating a few
objects—a pipe on a chair, for example—and carefully painting them, he could
regain his equilibrium. In his letters he speaks of the feeling of calm and well-
being that followed the making of such a painting. Not that Miró needed
reassurance on anything like the same level. His return to realism in this picture,
to those objects that for the previous twelve years had been indicated by
elliptical and often ambiguous signs, was certainly a function of psychological as
well as social distress and anxiety. The closing in on the objects—especially in
the absence of a familiar still-life context—endows them with an unexpected and
disquieting scale, and stresses their importance to the painter. There is
something distinctly obsessional about *Still Life with Old Shoe* beyond the fact
of the months of painstaking work Miró lavished on it.

(adapted from Rubin, *Miro*, pp. 72-74)

113

Une étoile caresse le sein d'une négresse (A Star Caresses the Breast of a Black Woman).
1938. Oil on canvas, 129.7 x 194.8 cm. Pierre Matisse Gallery, New York

Although Miró is one of the least political of artists, his anxiety before the increasing peril of Fascism and his anguish over the Spanish Civil War produced a considerable change in his art in the years between 1934 and 1938. During this period Miró executed many paintings that he has characterized as *tableaux-sauvages*. In these, the whimsy and gentle wit characteristic of his art give way to black humour, and the cursive, fluid line and saturated flat colours of his earlier period are abandoned in favour of a convulsive graphism, mixed colour, and ambiguous modelling. The incidence of *tableau-sauvage* imagery decreases sharply during 1938 and is rarely to be found in 1939, reflecting, we may assume, the onset of a new state of mind which the artist described in 1940: "I felt a deep desire to escape...I closed within myself purposely. The night, music and stars began to play a major role in my paintings..."

These elements were not, as Miró's words might suggest, brought into play for the first time in 1940. They had been at the very heart and substance of his art from the mid-1920s on. Although *A Star Caresses the Breast of a Black Woman* testifies to Miró's redirection of his art during 1938, the painting itself is not an exploration of uncharted territory, but a return to classic *miromonde*. Most immediately, it recalls the calligrammatic *tableaux-poemes* of the mid- to late 1920s, although the areas of high colour and smoothly brushed ground are more reminiscent of much of his work of the early 1930s.

A Star Caresses the Breast of a Black Woman is one of the rare paintings executed between the closing years of the 1920s and the early 1960s in which there is an emphasis on written poetry. Of this practice Miró has said, "I make no distinction between painting and poetry. It therefore happens that I illustrate my canvases with poetic phrases and vice-versa." The key word here is "vice-versa."

A composite ideogram of erotic experience, *A Star Caresses the Breast of a Black Woman* combines familiar hieroglyphs of Miró's pictorial vocabulary with ambiguously suggestive forms. Like the poetic phrase, the letters of which we read, the iconographically readable elements in the composition are outlined in white and float without substance on the enveloping black ground. To the left, described by the dotted line which in Miró's work often symbolizes movement, is an erect phallus inclined towards a schematically rendered vulva that terminates towards the left-centre of the canvas in four spider-like hairs—an image that occurs repeatedly in Miró's work and reminds us that he has spoken of "a woman's sex in the form of a spider." To the far right is a ladder, one of the most prevalent motifs in Miró's work, the significance of which, according to the writer Jacques Dupin, is finally that of "the escape ladder...symbolizing the power that Miró endows the artist with of being able to bring two worlds together without abolishing either of them...It stands for the accession to a higher reality without the sacrifice of the familiar reality..." As well, the ladder might stand for the sexual union that fuses the celestial and the earthly.

No specific allusiveness can definitively be given to the brilliant red and yellow forms that animate the surface of the canvas. But the delicately contiguous arrangement of the biomorphic red forms at the upper left and the red and yellow triangles at the right suggest fleeting couplings.

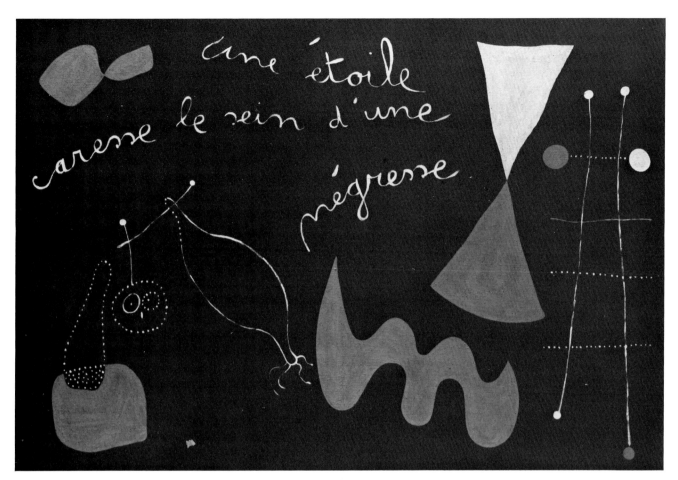

une étoile

caresse le sein d'une

négresse.

Plate 46

Resolutely "flat", *A Star Caresses the Breast of a Black Woman* nevertheless plays some subtle spatial tricks. Because they are so delicately drawn and because the black paint of the ground fills their contours, the readable elements seem to be situated within the blackness itself, whereas the denser white lines of the inscription, like the scattered red and yellow forms, are surface semaphores of interior action. The black ground itself acts simultaneously and interchangeably as a metaphor of the night sky and the body of the black woman of the painting's title. It is the magic space Miró invented to expand the mystery of poetry.

C.L.

The Ladder for Escape. (1940). Gouache, watercolour, brush and ink, 40.0 x 47.6 cm. The Museum of Modern Art, New York. Bequest of Helen Acheson

Between January 21, 1940 and September 12, 1941 at Varengeville-sur-Mer, Palma de Mallorca, and Montroig, Miró composed a series of twenty-three lyrical works. All were executed in the same technique and medium and all were painted on the same size paper. Miró's title for this series, *Constellations*, was especially appropriate since the works suggest the mysterious infinite space of the night sky and frequently produce a "constellating" effect whereby an arbitrary design is created by connecting points. André Breton, in discussing these works, relates how certain birds, while migrating, orient and direct themselves by the constellations, and accordingly concludes that the series deals with the idea of passage.

Freed from any conventional illusionistic or perspectival devices, Miró suggests an indeterminate, non-gravitational universe which may represent the landscape of the mind or of the cosmos. By saturating the paper with thin, irregular washes of paint, he creates a delicate, subtly modulated transparent ground which gives the illusion of an atmospheric firmament. The process by which Miró produces the correct surface sensation is described by Jacques Dupin: "On the moistened paper, sufficiently scraped or 'stirred to life' to bring out the texture, the hand engages in patient operations of rubbing, abrading, impregnating, massaging into life variously pigmented, variously somber or transparent gleams over the entire surface, realizing imperceptible transitions from one color to another or blending them in a single misty cloud. The grounds of the different gouaches are by no means the same, but all have a capacity for setting up vibrancies which create a living space and irresistibly summon up line, form, and pure color."[1] Through this process, which is particularly noticeable in *The Ladder for Escape*, one of the first works in the series, the delicately modulated grays partially-absorb all the other colours, in this case yellow, red, blue, green, and purple, to produce a luminous nocturnal atmosphere.

Upon this ground Miró floats small, flat, opaque, geometric shapes of pure colour: rectangles, circles, triangles, crescents, ovals (as well as a few of Miró's characteristic biomorphic shapes), all varied in size and number yet connected and held together by a system of filigree tracery. The filled-in coloured shapes (red, black, blue and white in *The Ladder for Escape*) and linear composition are suspended in front of the ground and enliven it with staccato accents. Miró's artistry is apparent in the balance he creates between the three elements.

Miró's painting was never wholly abstract. "For me," he explained, "a form is... always a sign of something." In the *Constellations*, we still find his poetic and enigmatic figures. In fact the firmament overflows with familiar forms: women, birds, suns, moons, stars, and particularly the night skies. In *The Ladder for Escape* for example, we see among many figures a biomorphic worm, a ladder to the sky, a figure which may be a kite and a crescent moon.

The period during which he painted the *Constellations* was a turbulent time for Miró. His intense mental concentration in working on this series at Varengeville-sur-Mer had been a type of interiorized escape in view of world-shaking events. With France threatened by the advancing German armies, Miró left the country and returned to Spain. The *Constellations* consistently explore the theme of escape, which is interpreted in part through music. Miró later said, "At Varengeville-sur-Mer, in 1939, began a new stage in my work...It was about the time when the war broke out. I felt a deep desire to escape. I closed myself within myself purposely. The night, music and stars began to play a major role in suggesting my paintings. Music had always appealed to me, and now music in this period began to take the role poetry had played in the early twenties, especially Bach and Mozart, when I went back to Majorca upon the fall of France."[2]

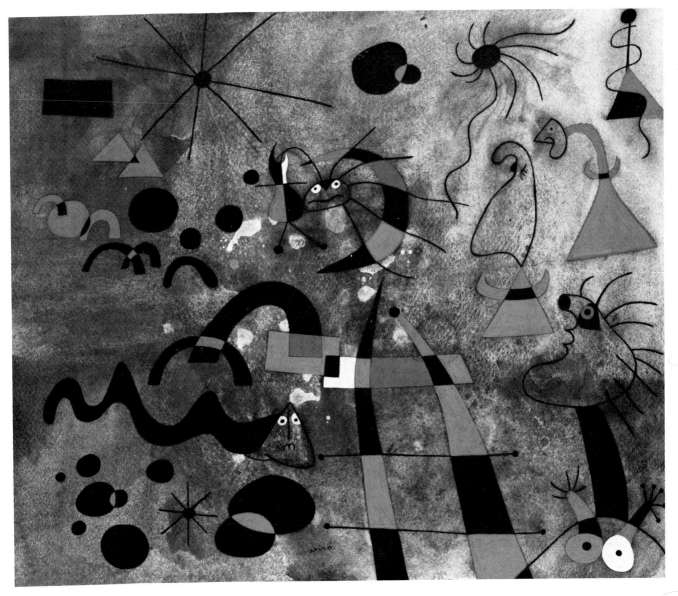

Plate 47

The ladder is a prevailing image in Miró's art of the 1920s, and is frequently associated with movement into distance or infinity. It appears regularly in the period of the *Constellations* in such works as *A Star Caresses the Breast of a Black Woman* (Plate 46) and continues into the early 1940s where it is more directly linked with the idea of escape. Miró recounts the developing meaning of this motif: "Another recurrent form in my work is the ladder. In the first years it was a plastic form frequently appearing because it was so close to me—a familiar shape in *The Farm*. In later years, particularly during the war, while I was on Majorca, it came to symbolize 'escape' an essentially plastic form at first—it became poetic later. Or plastic, first; then nostalgic at the time of painting *The Farm*; finally symbolic."[3]

L.R.

1. Jacques Dupin, *Joan Miró: Life and Work*. New York: Harry N. Abrams, Inc., 1962, p. 357
2. James Thrall Soby, *Joan Miro*. New York: The Museum of Modern Art, 1959, p. 100
3. Eliza E. Rathbone, "Joan Miró", *The Morton G. Neumann Family Collection*. Washington: National Gallery of Art, 1980, p. 41

Portrait of a Man in a Late Nineteenth-Century Frame.[1] 1950. Oil on canvas with ornamented wood frame, 146.0 x 125.0 cm including frame. The Museum of Modern Art, New York. Gift of Mr. and Mrs. Pierre Matisse

Miró's childhood friend Juan Prats, once a student of painting and later Barcelona's leading haberdasher, came upon this preposterously framed, pompous memorial portrait and sent it to the artist as a joke. The sitter is the epitome of the self-satisfied, pious, *bien-pensant* bourgeois; his pose and costume, the official medal and ribbon on his table, the religious pictures on the table and wall, and the rose garden visible through the window all allude to the secure, self-assured universe in which he functioned.

The deceased gentleman seems absorbed in lofty thought, his eyes directed heavenward. Possibly he is engrossed in complacent contemplation of a deservedly well-ordained afterlife. Into this vision, superimposed on the reassuring objects of the sitter's comfortable surroundings, Miró has mischievously inserted an unsettling dose of the unexpected and irrational—emblems of the unconscious and heralds of the unknown. As if to suggest the sitter's confusion at this interruption, Miró drew on his forehead a coil pattern, rather like a broken spring. On the rose garden seen through the window at the upper right are configurations familiar from the *Constellations* series (of 1940-41); in the upper right is the sign Miró uses to designate the vulva, and to the left are two long vertical and three short horizontal parallel lines enclosing little boxes of brilliant colour on which is superimposed an arabesque. In its resemblance to the treble clef, the latter makes the whole passage seem a kind of whimsical musical calligraphy—no doubt related to the singing of the bird.

The whole ambience has, indeed, been altered. By scraping away the paint around the sitter, Miró produced a suggestion of vague, unmeasurable space that, like a cloud of malaise, envelops the solid bourgeois. This space is totally at odds with the ordered illusionism of the original—determined as it was by precise coordinates—and derives ultimately from the atmospheric space of Miró's fantasy pictures of the mid-1920s.

Suspended in front of this space, situated on the picture plane itself, are a group of Miróesque symbols—the forms in the garden, a sharp-toothed little monster approaching the sitter on the lower right, a horned grotesque flying between the sitter's head and a blue cloud, and, below, a red disk with a white halo. All these signs appear to have been suddenly made manifest as if the picture plane were a kind of x-ray put before the sitter's conventional world, a visionary x-ray that reveals the metaphysical forces actually at work.

(adapted from Rubin, *Miro*, p. 85)

1. The title was given to the picture by Miró. Although the frame may in fact date from sometime shortly after 1900, its heavy ornamentation is characteristic of a kind of bourgeois, humourless, decorative style prevalent in the latter part of the last century. The title also certainly expresses Miró's vision of the sitter, whose life has been delimited within the "frame" of the nineteenth-century bourgeois mentality.

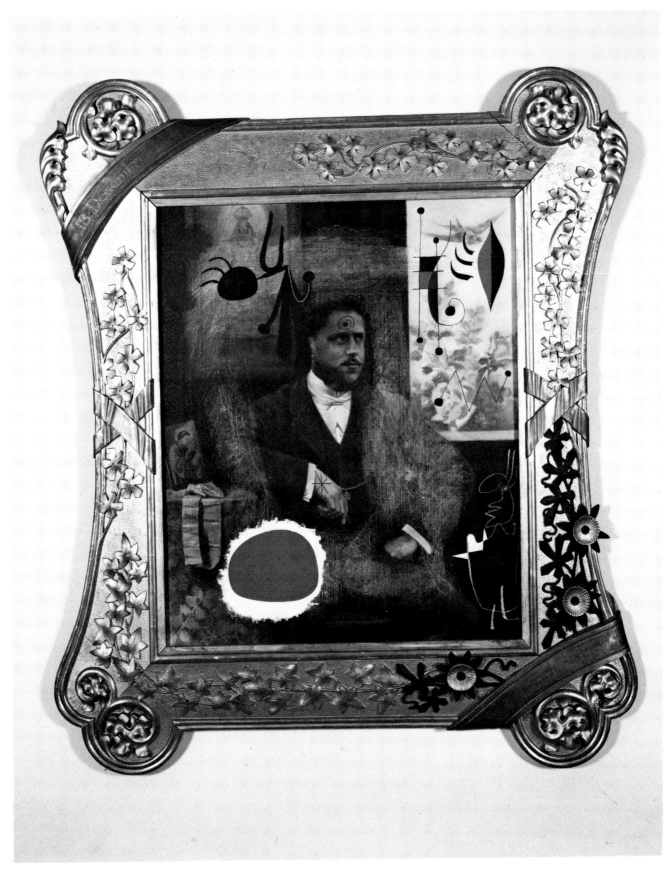

Plate 48

119

List of Principal Sources

Goldwater, Robert. *What is Modern Sculpture.* New York: The Museum of Modern Art, 1969.

Lippard, Lucy in *Three Generations of Twentieth-Century Art.* The Sidney and Harriet Janis Collection of the Museum of Modern Art. Foreword by Alfred H. Barr, Jr. and Introduction by William Rubin. New York: The Museum of Modern Art, 1972.

Rubin, William S. *Dada and Surrealist* Art. New York: Harry N. Abrams, Inc., 1968.

Rubin, William S. *Dada, Surrealism and Their Heritage.* New York: The Museum of Modern Art, 1968.

Rubin, William. *Miro in The Collection of The Museum of Modern Art.* New York: The Museum of Modern Art, 1973.

Soby, James Thrall. *Giorgio de Chirico.* New York: The Museum of Modern Art, 1955.

Soby, James Thrall. *Rene Magritte.* Catalogue of an exhibition organized by The Museum of Modern Art, New York and shown there December 15, 1965—February 27, 1966 and subsequently at: Rose Art Museum, Brandeis University, Waltham, Massachusetts, April 3—May 1, 1966; The Art Institute of Chicago, May 30—July 3, 1966; The Pasadena Art Museum, August 1—September 4, 1966; University Art Museum, University of California, Berkeley, October 1—November 1, 1966.

Soby, James Thrall. *The James Thrall Soby Collection.* Catalogue of an exhibition organized by The Museum of Modern Art, New York and shown at M. Knoedler and Company, Inc., February 1—25, 1961. New York: The Museum of Modern Art, 1961.

Photographs reproduced in this catalogue have been provided by the owners or custodians of the works indicated in the captions unless noted below.

Photography credits:

George Barrows: Plate 18
Hickey-Robertson, Houston: Plates 30, 33, 34
Kate Keller, Staff Photographer of The Museum of Modern Art, New York: Plates 12, 14, 47
Robert E. Mates: Plate 37
Robert E. Mates and Paul Kates, New York: Plate 43
James Mathews, New York: Plates 7, 26, 29, 42, 48
Rolf Petersen, New York: Plates 25, 28, 36
Soichi Sunami: Plates 1, 2, 3, 4, 6, 8, 9, 10, 11, 13, 15, 17, 19, 20, 22, 23, 24, 31, 35, 40, 41, 44, 45
Michael Tropea, Courtesy of The David and Alfred Smart Gallery, University of Chicago: Plate 39

Design by B. R. J. Michaleski Graphic Design
Printed and bound by Hignell Printing Limited